Digital Black & White Landscape Photography

Fine Art Techniques from *Camera to Print*

Gary Wagner

AMHERST MEDIA, INC. ■ BUFFALO, NY

Acknowledgments

The author acknowledges, with gratitude, his wife Susan for her encouragement, discerning comments, and assistance with this book. He also acknowledges Craig Alesse of Amherst Media for the production of this book.

Published by:
Amherst Media, Inc.
P.O. Box 586
Buffalo, N.Y. 14226
Fax: 716-874-4508
www.AmherstMedia.com

Publisher: Craig Alesse
Senior Editor/Production Manager: Michelle Perkins
Editors: Barbara A. Lynch-Johnt, Harvey Goldstein, Beth Alesse
Associate Publisher: Kate Neaverth
Editorial Assistance from: Carey A. Miller, Sally Jarzab, John S. Loder
Business Manager: Adam Richards
Warehouse and Fulfillment Manager: Roger Singo

ISBN-13: 978-1-60895-921-1
Library of Congress Control Number: 2015901206
Printed in The United States of America.
10 9 8 7 6 5 4 3 2 1

Check out Amherst Media's blogs at: http://portrait-photographer.blogspot.com/
http://weddingphotographer-amherstmedia.blogspot.com/

Contents

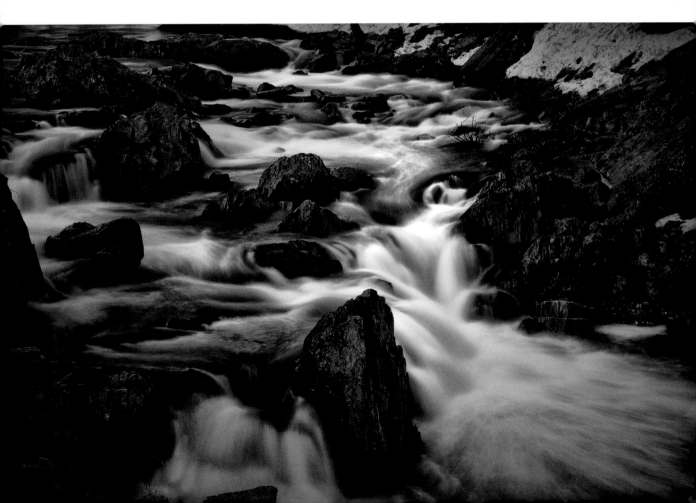

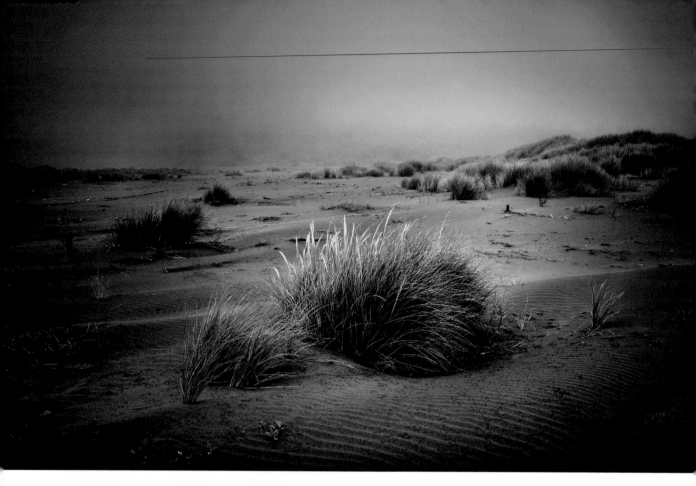

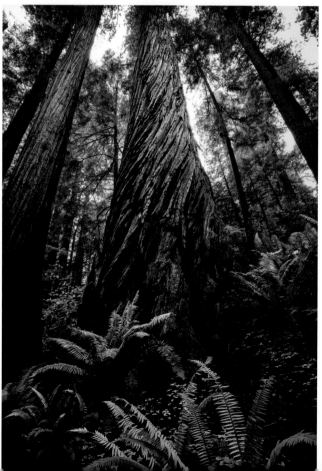

Coastal Seascapes

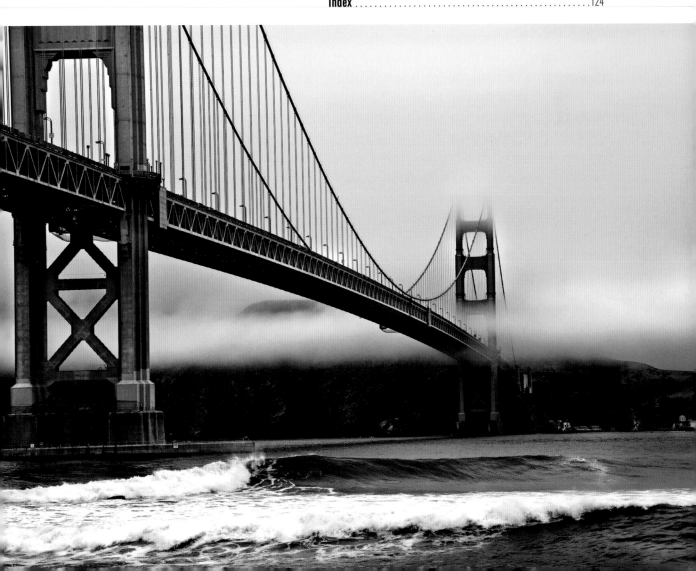

About the Author

Gary Wagner's love of photography began when he became the photographer for his high school newspaper in Kokomo, IN. He continued his education at Indiana University in Blooming-ton, eventually moving to Santa Barbara, CA, to attend Brooks Institute of Photography. While at Brooks, Gary increased his artistic and theoretical knowledge of photography and the historical significance of the printed image. Earning a master's degree in photography from Brooks Institute, with the publication of his work on historical carbon printing, gave Gary a continued appreciation and passion for his ar-tistic craft. Gary's professional career now spans more than three decades and includes fine-art, portrait, and commercial photography. His knowledge, expertise, and enthusiasm for the photographic image enabled him to successfully teach theory and technique at the college level and Eurpoean seminars on the English country landscape. Fluent with all film formats, from 35mm to 8x10, Gary has embraced the digital image and the ever-changing environment of photography in the current technological age. Exploring photography using digital imagery offers a myriad of possibilities. Refining tech-nique with the interplay of artistic expression fascinates and challenges Gary to continue his exploration of the photographic image and his study of the land's natural elements and beauty. For the past twenty-five years, Gary has made his home in the beautiful Sierra foothills of Northern California.

Introduction

A Little Background

I have been taking black & white photos of the landscape since I was a teenager living in central Indiana. At that time, I was working at a local camera store, taking photos for my high school newspaper, and trying to learn as much about photography as was able. In my spare time, I would drive the back roads of Indiana, taking photos of the Midwestern landscape with my Mamiya Sekor 500DTL 35mm camera, using Kodak Tri-X film. Later, at home, I would process the film and make prints in the bathroom. For the next several decades, my technique improved and my cameras became bigger and better—but I continued to use Tri-X and process the photos in a home darkroom.

Then, the biggest change to photography since the invention of color film was introduced: the digital camera. Being interested in all things related to photography, I followed the developments of the digital camera through the early years but did not believe it would amount to much. Who would have guessed, at that point, that the digital camera would take over the photography world and change the picture-making process completely?

Change did happen, though. I joined the new photographic wave and my process changed with it. While the big picture is similar to how photography was made in the old day of film (I still use a camera, I still process photos, and I still make prints), the change is in the details. Today, I use a camera that takes images on a computer card instead of film. Today, I process the images on my computer instead of in the darkroom. Today, I print with ink in the light instead of with chemicals in the dark.

I like the new process better and find the finished prints to be of equal or better quality than the photos that I made in the darkroom. The world of photography has changed and in my opinion it has changed for the better.

My Work

My work is primarily photos of the natural landscape and wilderness areas. I have also enjoyed taking photos of the urban or man-altered landscapes. Photography is my passion; whether outdoors on the trail in search of a spectacular scene of nature or walking on a city street, my goal is to capture that scenery for others to view and enjoy. My photography mentors include Ansel Adams, John Sexton, Paul Caponigro, and Michael Kenna. All of these photographers have captured images of nature and the landscape with unique style and beauty. The landscape that I seek includes all that is on the land and seas, whether natural or man-made, in our own backyards, in a national park, or the landscape of a far-off country. The opportunities are endless in terms of what exists to be photographed and what can be shared with others.

About the Book

This book is about black & white landscape photography images and how they are made. Included in the book are sixty primary images, featuring a variety of subjects and locations. Details are included on my actual photography process and the tools that are used to capture

images in the field. For each primary image, I've also included supporting images demonstrating the black & white conversion process and the enhancements that were made.

The book has been divided into sections by subject material. The sections on nature have been placed in the first four chapters of the book. A section of man-altered landscapes appears last, but the features are interesting and provide exciting photographic environments.

I work on images every day, enjoying the entire process, from the initial taking of the image to seeing the print roll out of my printer. I hope that photography also brings you this excitement and that this book will give you guidance and inspiration to make your own photography better and have fun doing it.

Equipment Choices

Camera. Many types of cameras can produce good results; there is no requirement that says you must use one over another. In fact, one of my favorite cameras today is the one in my phone; it is always with me and ready to take photos at any moment. There are several great applications to use with a phone camera and I also enjoy sending images to friends instantly so that others can enjoy them.

The camera I use to take images that will be printed is currently the Nikon 800E. My previous camera was a Canon Mark 5D Mark II. I upgraded to the Nikon, wanting the maximum number of pixels obtainable in a 35mm-size camera. Using the Nikon 800E, 16x20-inch prints (and larger) are comparable in quality to prints made from large-format negatives.

Almost any current model of digital camera will produce excellent images. If you are going to buy a digital camera today, I suggest purchasing the latest model, regardless of the manufacturer; the quality of the final image has historically improved with each revision.

Also, purchase a digital camera capable of saving the file in a RAW format. This will allow the production of an image with a wider dynamic range and offer greater flexibility for altering your images' densities and colors. The RAW format contains the maximum amount of information that the camera captured with its digital sensor. In landscape photography especially, you want every bit of this information.

Lenses. I employ a variety of Nikon lenses, including the 17–35mm f/2.8, 24–70mm f/2.8, and the 28–300mm f/3.5–5.6. I find that all of these lenses will produce quality images for black & white landscape work. The lens I use the most is the 28–300mm, finding it to be a universal lens—especially for traveling.

Tripod. The next most important part of picture-taking equipment is the tripod. The tripod used for most of my images is a Bogen/Manfrotto tripod with aluminum legs. I also used a Gitzo carbon-fiber tripod that is lighter and better for carrying over longer distances. For most of my work, however, a heavier tripod keeps the camera steady and less subject to wind movement. With my tripod, I use a Really Right Stuff BH040 ballhead. I find it to be of excellent quality and the perfect size for use with the Nikon camera. The compactness of the ball head and the ease of taking the camera on/off with the lever release is a great combination.

Other Accessories. I recommend adding a UV filter to each of your lenses. Keeping the lens in top condition and scratch-free is important. A filter can be replaced easily if it gets scratched, but it is much more costly to repair or replace a lens. Neutral density (ND) filters are also helpful when taking photos of water. I have several ND filters and use them in different combinations depending on the intensity of the light and the speed of the water. Another helpful accessory is a waterproof camera cover to use when taking photos in the rain or fog.

You'll also need bags to transport and protect your gear. If I have several miles to hike to a location, I stow my camera in a backpack; for shorter treks, I use a shoulder bag. The shoulder bag is preferred because I can take out the camera and change the lens without having to take the bag off my shoulder. If the conditions are wet or snowy, not having to set my gear on the ground is a tremendous advantage.

Camera Setup and Shooting

Time of Day. A great majority of my landscape photos are taken just before or after sunrise. The first hours of the day contain that magic light that is so important to making outstanding landscape images. Similar qualities of light can be found in the last hours of the day, so dusk is also a favorite for taking photos. I am often on the road before sunrise with a predetermined location chosen for the morning photo session. Many times, this has been scouted during the previous day, so I know the terrain and what I want to photograph. Avoiding basic unknowns is a plus for me. Time is precious in the early morning; the difference between a good shot and a great shot can be just seconds.

Stabilize the Camera. I use a tripod for 99 percent of my shots. (The exception is when I'm traveling and a tripod is disallowed or too heavy to transport. My travel images are mostly hand-held, single-shot images.) When I am moving from one location to another that is in close proximity, I leave the camera on the tripod between photos. I only remove it when I am moving to a distant location, when the terrain is hazardous, or when the weather is inclement.

ISO. My camera settings are standardized for most of my photography. I set my ISO at

100, which is the lowest setting on my camera, enabling me the best possible image quality.

File Format. I also photograph all of my images using the RAW format, the best and most versatile file format. If your camera only saves images in the JPEG format, experiment and seek knowledge and experience to maximize the picture-taking and -making process. I have several point-and-shoot cameras that only save JPEGs and I never hesitate to take a photo if it is one I like and want to share with others.

Exposure Mode and Aperture. Shooting in aperture priority, my camera is set in the f/11 to f/16 range for most of my photography. My goal is to get the best quality image, and I know that this aperture range works well with my camera and lens. I do use wider aperture for scenes where I want the background to be out of focus. Smaller apertures are used for scenes that require an extended depth of field with objects in the near foreground.

Bracketing. I set my camera to five-exposure auto-bracketing in 1-stop increments. This gives a normal exposure, +1 stop, +2 stops, –1 stop, and –2 stops. With my Canon camera, I was able to set the camera to +2 stops and –2 stops and only took three images of each scene. With my Nikon camera, however, there is a maximum of 1 stop for exposure bracketing, requiring five exposures to cover the same stop range that the Canon camera did in three. One advantage of the Nikon camera is that it can take seven or nine bracketed exposures—which is useful when photographing extremely high-contrast scenes.

I use this bracketed exposure method whether or not I plan to use HDR processing. I find it gives me the most options when processing my images. Using this technique, I never worry about using the camera's auto-exposure setting and if it is working correctly or not. As long as the correct exposure is somewhere in the 5-stop range, I have it covered.

The one disadvantage to this exposure method is the amount of memory required on the camera's storage cards and on the computer's hard drive. The Nikon images are 73MP RAW files and image storage is used up quickly.

For those who do not have a camera that allows for auto-bracketing, manual bracketing can be done for scenes where you intend on doing HDR processing of your images.

Shutter Delay. The only other important setting on my camera during image taking is a 5-second shutter delay prior to taking the first image. This helps minimize camera movement and vibration for the first image taken.

Image Evaluation

On the Camera. I check my images on the camera's viewing screen during and after taking the images. This is done to make sure that the camera is functioning properly, that the exposures are in the correct range, and that I have set up the camera properly. When looking at images on my camera, I use the in-camera histogram view to be certain that the normal image is exposed properly.

On the Computer. The next part of the image-making process occurs after the images are taken. With the wonders of modern digital technology, I can download the memory cards and view my images within hours (or minutes) of taking them. Reviewing the final image on your computer, or on paper, is the best way to improve your technique and produce better photos. Without the cost of buying or processing film, the reasons for limiting our picture taking have all but vanished. Take advantage of this new technology and use it to make yourself a better photographer.

Software

Having the proper software and learning how to use it effectively is key to making the best black & white landscape images. I have divided this section by software types and how I use them. My goal is to define what software I use when making black & white images. I have added the basic steps I use with each, giving you a starting point for creating black & white images. As you'll see in the following sections of this book, these steps are implemented with many images.

Image Viewing. There are many image viewing programs available on the market. I will mention the two I use for my work.

Adobe Lightroom does an excellent job of quickly and easily importing images from your memory card and creating thumbnail images so you can view and sort them. In addition, the program now offers many of the same editing tools as Photoshop, including an excellent black & white conversion tool. Print and web export functions are also included.

Occasionally, I have used many of these functions with my images—but my primary use of the program is for viewing and sorting images. The steps for importing images into the Library are fairly direct after learning the basics of how the program works.

The other program I use for viewing images is BreezeBrowser by Breeze Systems of the UK. This program is basic in comparison to Adobe Lightroom but does a good job of presenting images for viewing and allows images to open easily into Photoshop. The program is reasonably priced and has continually been updated for new camera models.

Adobe Photoshop. After my images are imported, I review them in Lightroom and open the chosen images in Adobe Photoshop for editing. (*Note:* This is my process for single images.

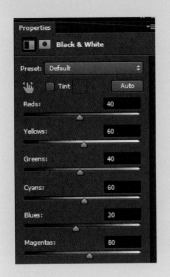

◄ Black & white conversion.

For editing multiple images I use a different process that will be explained later.)

Compared to the capability of the program for total image editing, the tools I use are relatively limited. Some of these tools and how I use them will be discussed. The majority of these tools create a new layer for the image and can be adjusted repeatedly or at a later time.

The first tool I normally use is a Black & White adjustment layer. This produces excellent results for images that require a basic conversion from color to black & white, without any special adjustments added.

I create a new Black & White adjustment layer and then use the Preset drop-down box to choose from a number of color filters that give me a starting point for converting the image. I normally try all of the color presets and select the one that visually works best with the image. Next, I adjust the color sliders below the preset in both directions to see how they alter the image tones. Often, I find this gives me the results I am looking for and I finalize the conversion process during this step. For other images, the results do not meet my requirements and I move on to other software, which will be discussed in upcoming sections.

▲ Adjusting the Levels.

▲ Adjusting the Curves.

▲ Adjusting the Brightness/Contrast.

The second tool I use frequently is the Levels tool. This lets me adjust the tonal range of the image so the tones completely fill the histogram (from black to white). Images that do not fill the histogram often look washed out and lack the rich black tones needed. I move the left (black) slider under the histogram by two or three numbers so that the finished print will contain a minor black area for maximum contrast. I use the same process with the white slider on the right side of the histogram, moving the slider to the left until it touches the first white on the histogram. This helps to retain detail in the light parts of the image and create a true white. The middle slider is used to adjust the midtones of the image. Its normal position is at 1.0. My usual process is to move this slider in both directions to preview the results and determine if the appearance of the image has improved with its movement.

The Curves tool contains a drop-down list of presets. The one I usually pick is the Medium Contrast adjustment. Occasionally, this makes the dark tones overly deep, in which case I place the cursor on the lower portion of the adjustment curve and raise it up slightly to lighten the dark areas of the print. I seldom adjust the

white part of the curve, but it can be done if the white areas are too dark or light. This tool gives excellent results in altering the contrast of the image and it is used on many of my images.

I also use Brightness/Contrast adjustment layers to lighten or darken the entire image or to further adjust the contrast of the image. If I find some general adjustment is necessary after using the Curves tool, the Brightness/Contrast let me further refine and enhance the contrast of the image prior to completion.

The Spot Healing Brush and Clone Stamp tools are used on almost all of my images to correct camera-sensor dust spots. These spots are primarily observed in the sky portion of images—and I have found that the black & white conversion process greatly accentuates these spots. My process is to enlarge the image to 100 or 200 percent and visually scan the image sec-

▼ Camera sensor dust spots.

tion by section as I use the Spot Healing Brush or the Clone Stamp tool to remove any spots I observe. If only small prints are going to be made, minor spots don't need to be eliminated. For large prints, however, it is critical that all spots be removed.

Photomatix Pro. 5.0. For the vast majority of my images today, I am using HDR (high dynamic range) software to combine multiple exposure-bracketed frames into one image. The purpose of the process is to obtain the maximum amount of highlight and shadow detail in the digital file. There are many programs available to do this (including a program supplied with Adobe Photoshop). The program that I use on a regular basis is Photomatix Pro 5.0 by HDR Soft. I find this produces the best results for my images—and it not only works successfully with multiple images but also with single images. As noted, when traveling I often shoot single images because I do not have a tripod available to do precise exposure bracketing of each subject or scene. For these images, I use the single image feature to maximize the tones and detail of the photo.

With bracketed images, my normal process is to import the files and choose one of the many preset image options that are available. In most cases, I am not looking to make the image look overly enhanced by the HDR process; I just want to improve the tones and detail. Photomatix can be used as a standalone software or as a plugin for Photoshop or Lightroom.

Nik Silver Efex Pro 2. The final software that I want to discuss is Nik Silver Efex Pro 2. For the majority of images in this book, this is the software I used for converting the color captures to black & white. (The others were converted with Photoshop Black & White adjustment layers, discussed in the previous section.)

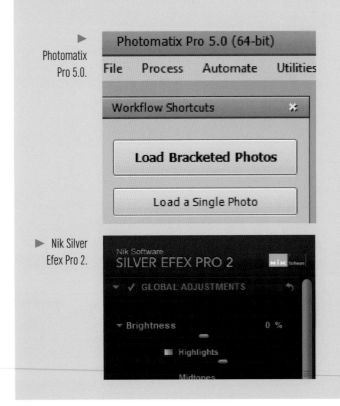

Over the past ten years, I have tried most of the black & white conversion techniques and software on the market. In recent years, however, I have settled on Nik Silver Efex and generally use it on a layer within Photoshop. I like this program's large variety of preset options and the great flexibility it provides to alter the tones and contrast of my digital images.

Conclusion

This consideration of camera equipment and software selection and usage has covered the fundamentals of how digital black & white landscape images are produced. As we move forward into the book, I will further define how this process was implemented in a large variety of images with a step-by-step visual outline. Digital black & white photography is part technology and part art—and the following discussions will give you a solid understanding of both aspects.

Lakes and Streams
Bonsai Rock
Lake Tahoe, NV (2012)

Shooting

Bonsai Rock is a famous location for photographers. The beauty of the location and the unusual vegetation growing out of this isolated formation make it an iconic setting. I photographed it early in the morning, prior to sunrise, with soft light and placid water. I used a 2-stop neutral density filter on the lens to lengthen the exposure so the water became softer and smoother. The exposure for these images ranged from .8 seconds to 13 seconds.

Postproduction

This photo was created by combining three bracketed images in Photomatix, using the Painterly preset with the Normal+ lighting adjustment. Next, the images were converted to

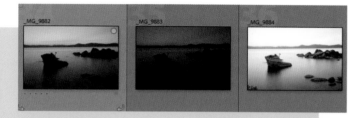

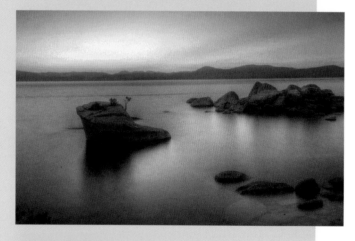

◀ *Top:* Three bracketed color exposures were taken: normal, -2 stops, and +2 stops. The normal exposure was 3.2 seconds at f/18.

◀ *Center:* Combined image using Photomatix.

▼ *Below:* Black & white conversion using Nik Silver Efex.

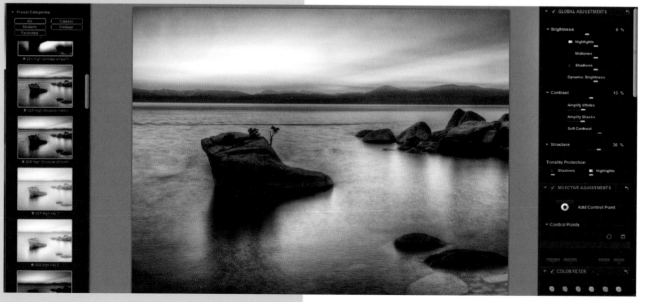

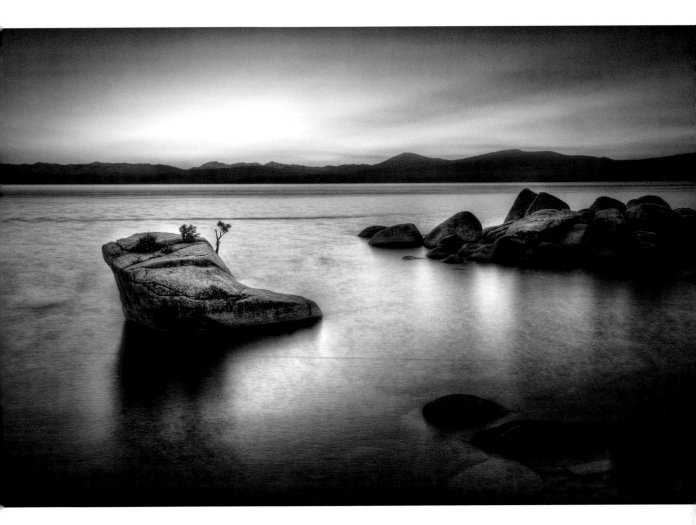

▲ Final image.

black & white using Nik Silver Efex Pro, with the High Structure Smooth preset. This preset increases detail in the image but also makes it softer in appearance. Finally, in Photoshop, I darkened the borders of the image, enhanced the center of the image, and adjusted the Brightness/Contrast and Levels for printing. Sharpening, using the Unsharp Mask filter, was also applied in Photoshop.

Artistic License

During the bracketed exposures, a boat traveled over the lake and created a darker line of water in the center of the image. I found this line to be distracting and removed it in Photoshop.

Also, some smaller rocks visible to the sides of Bonsai Rock were removed.

I use artistic license to alter images as I feel is needed to show my interpretation of the scene. Altering images to fit the emotional or visual intent of a captured scene brings creative satisfaction and adds to the photographic process.

❝ I use artistic license to alter images as I feel is needed to show my interpretation of the scene. ❞

Two Waterfalls

South Yuba River, CA (2012)

Shooting

Finding exceptional compositions on rivers is always a challenge. Seeing these two waterfalls close to each other, I knew this was my chance to create a standout image.

The river was located a significant distance from the road, and I had to climb down several hundred feet of rock to get to the water. Using my tripod, I set up my camera with a 17–40mm wide-angle lens just at the edge of the water. I added a 3-stop ND filter over my lens to decrease the shutter speed to 6 seconds for the normal image. Then I took a series of three photos, including normal, −2 stops, and +2 stops.

The light on the water was of particular interest in this image. I wanted the viewer's eyes to travel from left to right and back to front. The sky was initially visible above the trees in the background. However, most of it was cropped

 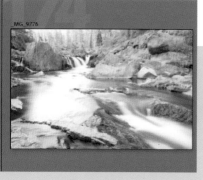

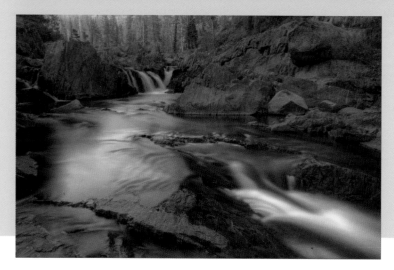

▲ Three bracketed exposures were taken: normal, −2 stops, and + 2 stops. The normal exposure was 6 seconds at f/16.

◄ The color image after processing in Photomatix.

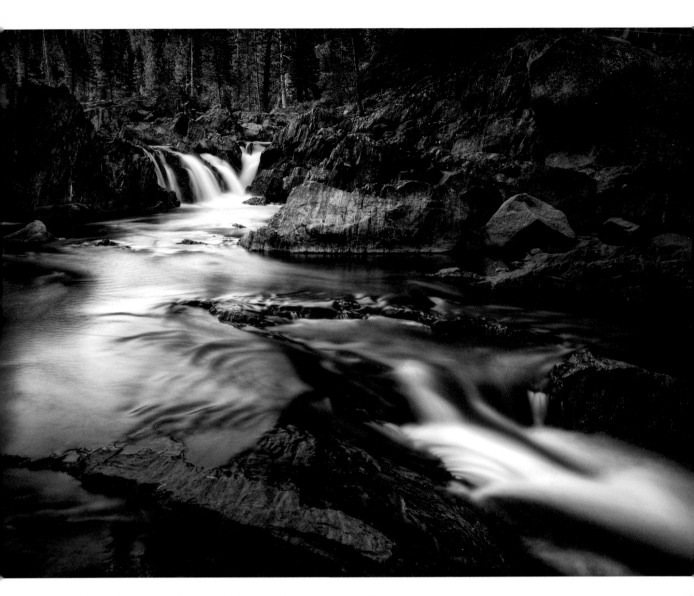

out in the final presentation of the image. It was not a main part of the subject and I found it distracting to the overall composition.

▲ Final image.

Postproduction

Three photos were used for this image. The images were combined in Photomatix to give the maximum detail in the high tones of the water and the low tones of the rocks. The image was then further processed in Nik Silver Efex to convert to black & white with the edges burned in about 10 percent. Finally, the image was

moved into Photoshop and the rock in the center was dodged 10 percent to make it minimally brighter. I also used the Levels in Photoshop to darken the blacks by moving the left slider to 4; I moved the highlight slider to 245, brightening the whites in the water. Finally, I used the Brightness/Contrast function to bring the whites to a good printing density. I upped the Contrast to give the image a little more snap.

Rock in Stream

Tahoe City, CA (2013)

Shooting

This boulder is located in the Truckee River, not far from Tahoe City, CA. I have photographed it many times in a variety of seasons. This image (my current favorite) was taken in April, 2013, during the first hour of light. The sun hits this spot in the river early in the morning, so to avoid unwanted sun spots and shadows, one must rise with the birds. I found this shot arresting due to the dynamics of the boulder and the reflections in the water.

Postproduction

I photographed this image with a Nikon 800E and a 28–300mm Nikon lens at f/14 and around 1 second for the normal exposure. The bracketed images were combined in Photomatix using the Painterly setting. The image was then opened in Nik Silver Efex. Using the normal setting, I lightened the boulder and darkened the background to emphasize the rock. Finally, the image was opened in Photoshop and the Levels were used to add blacks by moving the left slider to 4. Next, I used the Lighting Effects filter to further add light to the boulder, giving the boulder greater contrast against the water and the background. Last, I adjusted the Brightness to correct the highlight density to 245 for printing and adjusted the Contrast upward, to up the contrast of the total image.

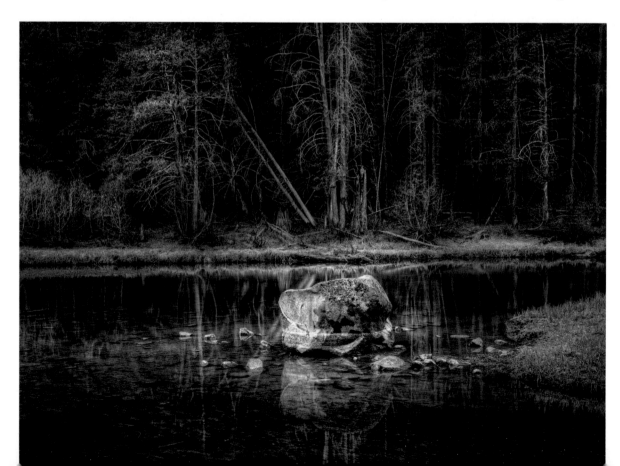

Rushing Water and Rocks

Sierra Mountains, CA (2012)

Shooting

Standing on a rock next to a raging river with your camera and tripod in hand can be a thrilling experience—but a certain amount of caution should be practiced. Ending up in the water (with or without a camera) is *not* thrilling! Therefore, a few words of safety and caution: I always have my camera strap attached to the camera and around my neck, whether I'm using a tripod or not, and I never stand too close to the edge.

Postproduction

This photo was made from a single image that was converted to black & white using Nik Silver Efex. The High Structure Smooth preset was used to give detail to the rocks and water. In Nik, I also lowered the Brightness to –12 percent and raised the Structure to 42 percent. Both of these adjustments were done to increase the texture of the light and dark areas of the image. Back in Photoshop, I created an adjustment layer for the upper rocks to darken them. This allowed the water to stand out more. I also darkened the upper right corner of the frame and the rock at the bottom center of the image. Finally, some selective dodging was done on the water to fine-tune its brightness.

With these adjustments, the image finally matched my vision for the scene.

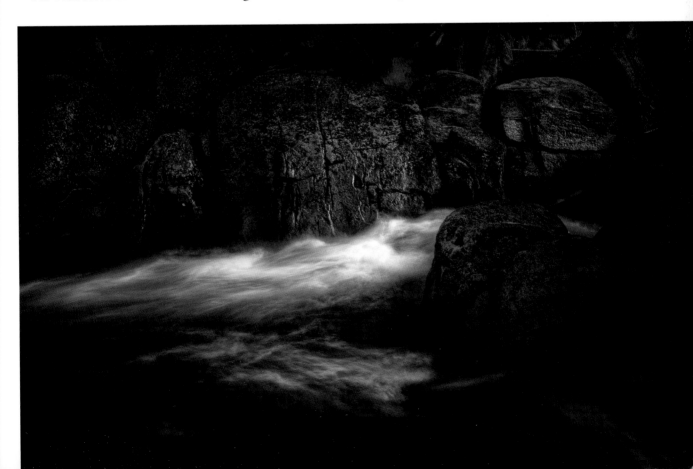

Water with Rocks

Lake Tahoe, CA (2009)

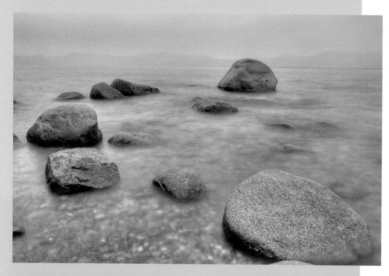

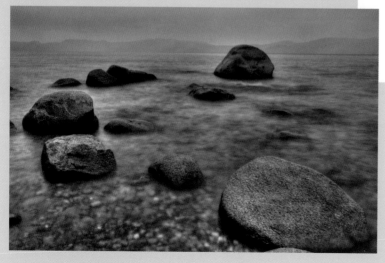

Shooting

This image was taken on a cloudy morning on the west side of Lake Tahoe. Clouds in the morning afford us more time to work before the rising sun begins casting bright spots on the landscape—and making significant shadows. The majority of my work is done on cloudy days or before the sun appears in the morning. I find the look of the light at these times more appealing for the images I am creating.

Postproduction

In Photoshop, I used the Lighting Effects filter to enhance the light in the center of the image and darken the background. I then used the Levels tool to darken the blacks and further lighten the whites. Next, the Curves tool was used at the Medium setting to boost the contrast. The Clone Stamp tool was used to remove the horizon line and the

◄ *Top:* Three bracketed exposures were taken: normal, -2/3 stop, and +2/3 stop.

◄ *Center:* The images were combined in Photomatix using the Default preset and the Medium lighting adjustment.

◄ *Bottom:* In Silver Efex, the Underexposed preset was used. The Structure was increased to 11 percent and the yellow filter was chosen with the strength at 32 percent.

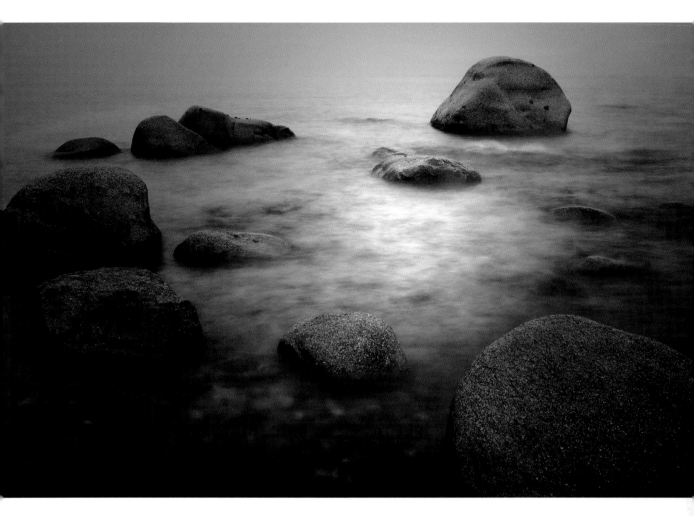

background mountains and sky. Finally, I used the Dodge and Burn tools to further lighten and darken selected rocks. Some images require very little manipulation to achieve the desired look, while others require considerable time. To achieve the look I wanted with this image, I spent many hours working on it in Photoshop.

▲ Final image.

▲ Applying the Lighting Effects filter in Photoshop.

66 Clouds in the morning afford us more time to work before the rising sun begins casting bright spots on the landscape – and making significant shadows. 99

Sierra Snow Melt

Sierra Mountains, CA (2012)

Shooting

Spring snow melt is an exciting time for mountain photography. During the winter, many of the high mountain rivers are frozen over and covered in snow, leaving very little water movement to be included in winter snow images. When spring comes and the snow melts, the rivers become exuberant and dramatic locations for water photography.

This location on the western side of the Sierra Mountains in California was a superb spot due to the many rocks and water diversions in the river. In addition, it was an unusual location that allowed me to shoot (on land) with the water directly upstream from the camera. I never shoot standing in the water, as the speed and temperature make it an unsafe situation.

I shot three bracketed frames: a normal, a +2 stop, and –2 stop exposure. The normal exposure was at $1/20$ second at f/10, which was an adequate shutter speed to capture detail in the water. A longer shutter speed would have created a softer image.

Postproduction

Combining three images allowed me to retain adequate detail and highlight the force and dynamics of the water. The three images were combined in Photomatix to increase the detail in the very light water and the darker rocks of the scene. The Painterly preset with the Natural lighting adjustment was used in Photomatix. The black & white conversion for this image was completed using Nik Silver Efex with the Wet Rocks preset. I increased the Structure setting to 24 percent for this image. Finally, in Photoshop I used the Brightness/Contrast and Levels tools to fine-tune the tones for printing and final viewing.

◀ *Top:* The bracketed images combined in Photomatix.

◀ *Bottom:* Black & white conversion using Nik Silver Efex.

▶ *Facing page:* Final image.

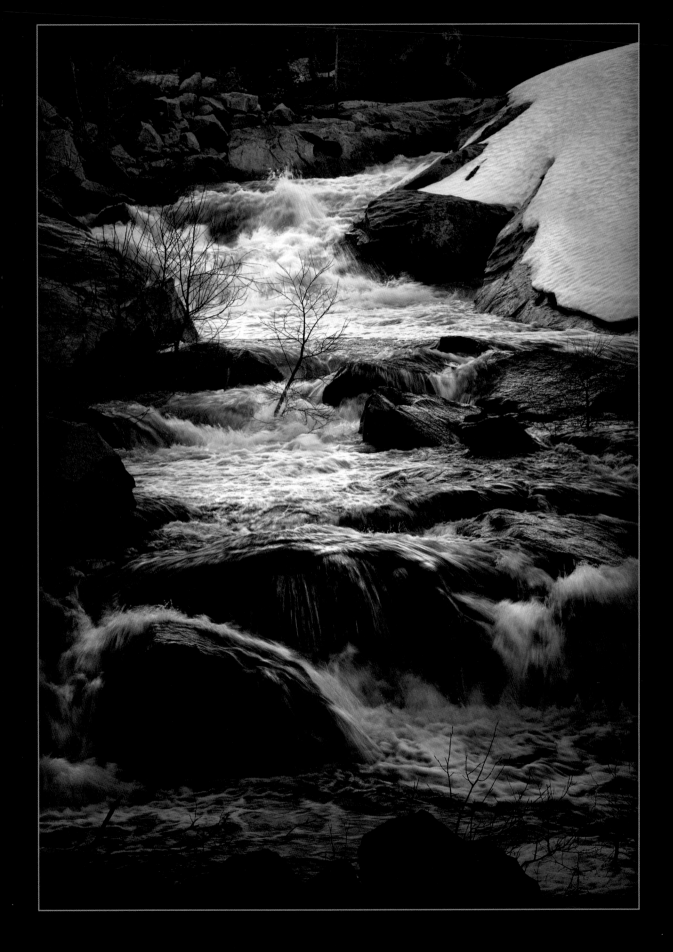

River Grass

Truckee River, CA (2012)

Shooting

This image was made on the Truckee River near Lake Tahoe in Deccember. The weather was cold, however there had not been much snow and the only real sign of winter was the ice on the foreground grasses.

The single grass strands, still standing in the middle of the image, were the subject I decided to concentrate on. The light on the grass and water is a key element in making this image successful. Isolating the subject through composition, lighting, and tones will create a dynamic black & white image and a successful print.

I also wanted to add a sense of motion, so I shot my bracketed frames using long shutter speeds. When combined, the images showed

> 66 The creative vision for this image was soft and delicate lighting, hinting at the river flowing in the background. 99

movement in the grass strands, which made the image more interesting. Blending those five images also enabled me to capture a blurred appearance on the river in the background.

Postproduction

The five bracketed shots for the final image were combined in Photomatix using the Painterly setting with Natural+ lighting adjustment. The image was then opened in Nik Silver Efex and

▼ Five bracketed frames were taken for this image: normal, –2 stops, –1 stop, +1 stop, +2 stops. The normal exposure was 1.3 seconds at f/18.

▶ The resulting color HDR composite in Photomatix, made with the Painterly preset and the Natural+ lighting adjustment.

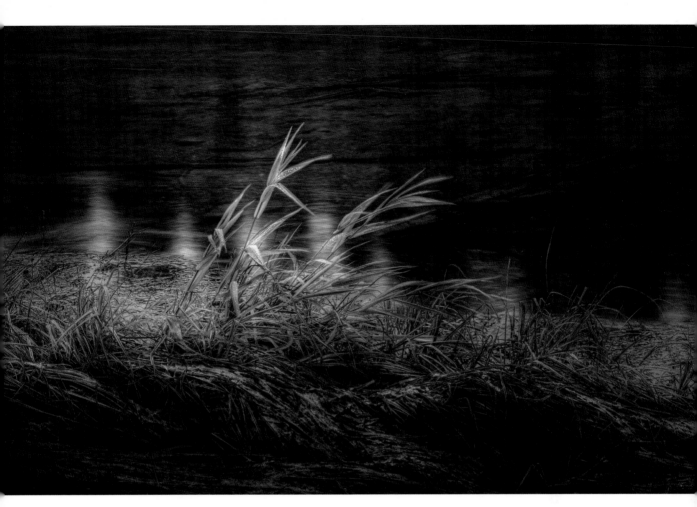

the High Structure (Smooth) preset was used to convert the image to black & white. A reduction of highlight density was also made in Nik.

The image was then transferred to Photoshop where final adjustments were made using the Brightness/Contrast tool to darken the water in the background and the foreground grasses. The standing grass blades were also

▲ Final image.

adjusted to give the best final printing density for the image.

The creative vision for this image was soft and delicate lighting, hinting at the river flowing in the background.

► Nik Silver Efex black & white conversion.

Sierra Spring Snow Melt

Sierra Mountains, CA (2013)

Shooting

Moving water is one of my favorite subjects. I am especially attracted to rivers and streams with dynamic water flows. This photo was taken in the spring, as the melting winter snows sent waters rushing downstream.

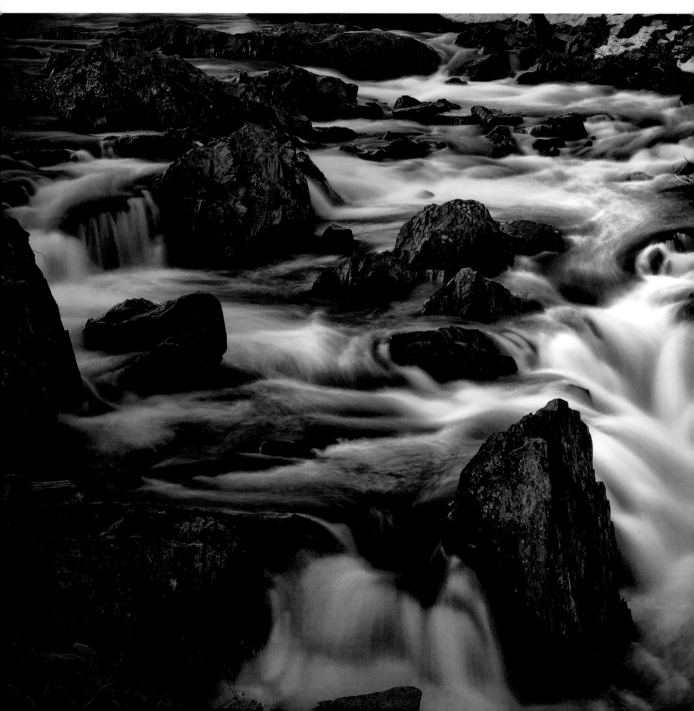

I used a 3-stop ND filter to enable the selection of a longer shutter speed. I like the softness of flowing water this produced. I often shoot at a few shutter speeds, then determine the best result when inspecting the shots at home in front of the computer. It can be difficult to review images in the field, where paying attention to the photo-taking process and your personal safety is critical. In this case, I was standing on wet rocks and very close to rapidly running

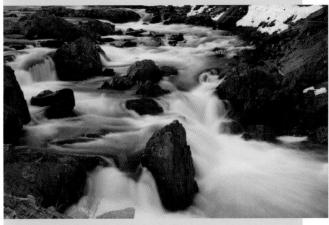

▶ Exposure, 2.5 seconds at F16

▶ Nik Silver Efex black & white conversion

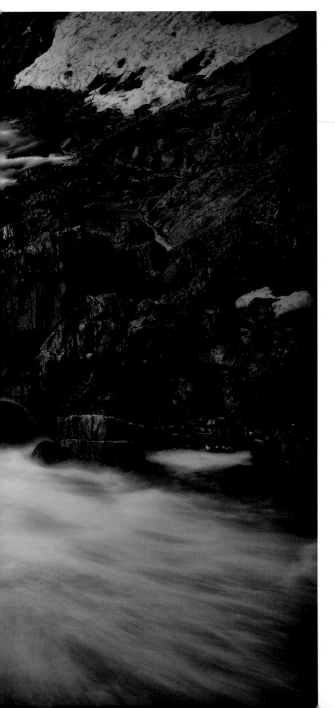

water. In such an environment, you want to give the environment your full attention and avoid any unintended consequences.

Postproduction

The single image for this photo was converted to black & white using Nik Silver Efex with the High Structure (Smooth) preset. I also darkened the edges of the image to further enhance the center of the photo. In Photoshop, I made Brightness/Contrast adjustments and sharpened the image to make it ready for printing. As with most images, I also adjusted the left slider in the Levels dialog box to create some true blacks. Although the adjustment is minor, the presence of a true black enhances the richness of the final image. Here, the dark Levels slider was only moved from 3 to 6 on the scale.

Lakes and Streams

Early Morning Sun

Lake Tahoe, CA (2014)

About This Image

This image was taken early in the morning with the filtered sun gently shining through the clouded sky. It was made by combining five images taken with shutter speeds ranging from 2 seconds to 30 seconds. In order to reduce the light for the long exposures, I had to stack several ND filters on my lens. One issue of filter stacking is the problem of corner vignetting, due to the filters blocking the light from the sensor. A better option would have been to use *one* ND filter with greater density—however, on this day I did not have that filter, so I used the ones on hand. I find photos with long exposures are soft and beautiful with almost magical lighting and cloud effects.

Postproduction

The bracketed photos were combined in Photomatix using the Painterly preset. The black & white conversion for this image was done in Nik Silver Efex with the High Structure (Smooth) preset. In Photoshop, I used the Healing Brush tool to remove the vignetting in the corners of the image. Finally, I adjusted for Brightness/Contrast and Levels prior to printing.

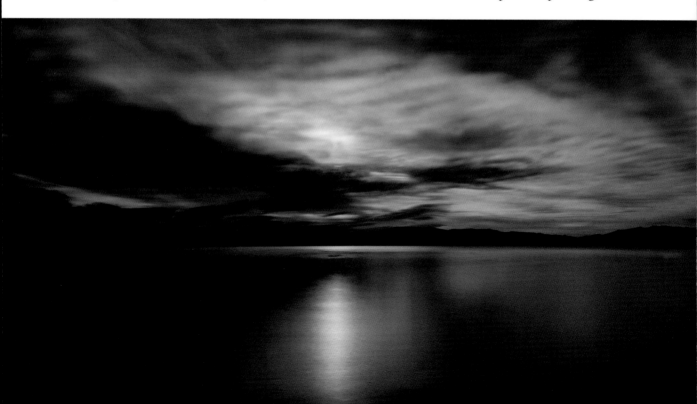

Light and Trees Reflecting in Water

Sierra Mountains, CA (2012)

Shooting

When taking images, look for instances where light interacts with the elements of the scene. In this case, the sun shining in the east was illuminating the sky and reflecting in my image, but it was not high enough to shine directly onto the rocks or water. It is important to look around in all directions for images when you are taking photos. Many of the best images are not where you expect them to be; it's easy to miss opportunities if you're not perusing the whole area.

Postproduction

Three bracketed images were combined together in Photomatix using the Painterly preset and the Normal+ lighting adjustment. The density of the whites was also reduced to provide greater detail. The image was opened in Nik Silver Efex for conversion to black & white using the Low Key preset with the yellow filter at 29 percent. The midtones of the rocks and the dark areas of the trees were also darkened for greater contrast against the light on the water. Finally the image was brought over to Photoshop to further darken the rocks using Brightness/Contrast and to refine the final densities prior to printing. The Unsharp Mask filter was also applied to sharpen the image. Typically, I use a standard sharpening of 70. The final amount depends on the size of the print I am making. Often, applying local sharpening to specific areas of the image will produce a better print.

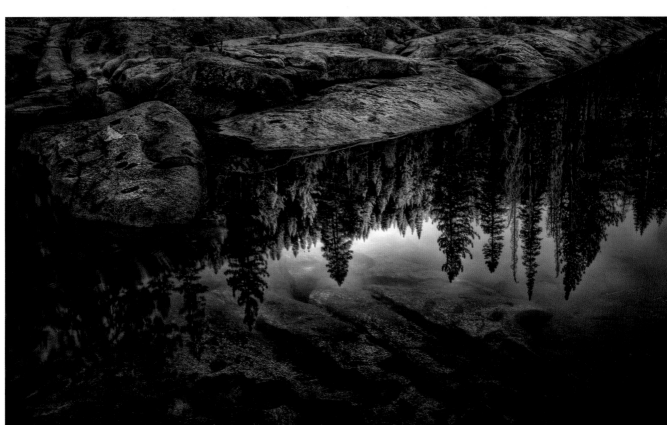

Lake with Ice and Tree

Sierra Mountains, CA (2009)

Shooting

This image was taken on a cold November morning in the Sierra Nevada Mountains. As I first looked at the lake, my interest was in the tree in the frozen water and the collection of snow that had settled on it. Looking longer at the scene, I also saw interesting shapes in the ice and the reflections of trees on the water.

▲ Three bracketed exposures were made for this image: normal, -2/3 stops, and +2/3 stops. The normal exposure was at 1/8 second and f/16

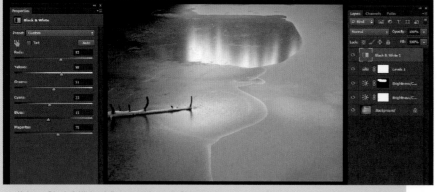

▲ Using a Black & White Adjustment Layer in Photoshop.

▲ Nik Silver Efex black & white conversion.

Postproduction

Three bracketed exposures were made of this scene, but only the normal exposure file was used to make the final image.

I used both a Photoshop Black & White adjustment layer and Nik Silver Efex to do the black & white conversion. I began with the Black & White adjustment layer in Photoshop, moving the sliders to produce a look I liked. Upon review, however, I decided that further enhancement was needed. Opening the image in Nik Silver Efex, I used the High Contrast (Smooth) slider.

The image was then returned to Photoshop for further adjustment using the Brightness/Contrast tool. Local dodging and burning achieved the enhancements needed to produce my final vision.

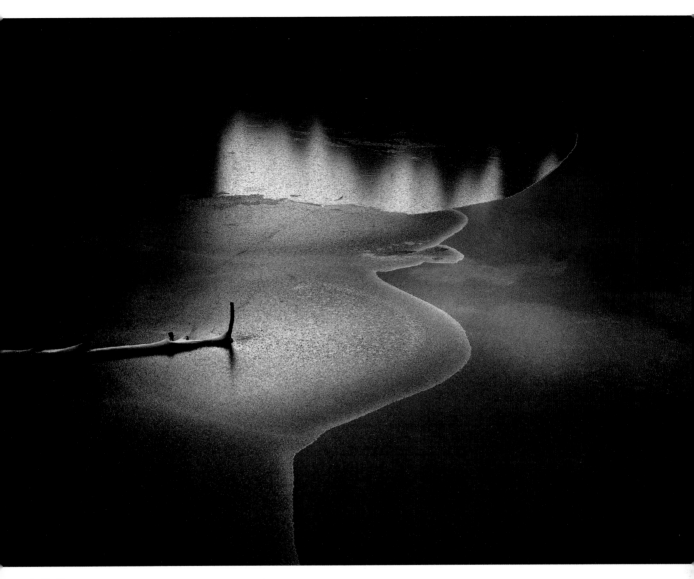

▲ Final image.

Artistic Vision

As can be seen by the bracketed photos, the final image is presented quite differently from the way the actual scene appeared. Many times, I alter my black & white photographs to produce abstract images or transform the content of the image so that it is not easily identifiable. In this case, I adjusted the brightness and contrast to highlight the portions of the image that would draw the viewer's attention to where I wanted

it. When I worked in the darkroom making traditional prints, I accomplished the same thing by burning in and dodging parts of the image under the enlarger light. Photoshop makes this process much easier—with the added bonus of less paper usage to achieve the same effect.

Trees and Rocks

Redwood Forest

Redwood National Park, CA (2012)

Shooting

Taking photos of redwood trees can be a challenge. The lighting in a redwood forest often varies, with darkness, fog, or streaks of light coming from the overhead sun. Early morning images of redwoods, made prior to the rising of

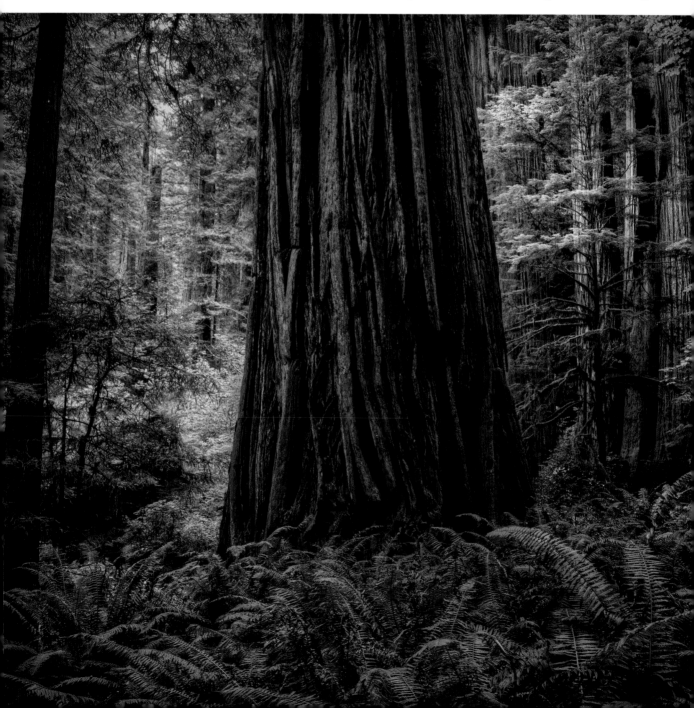

the sun or soon after sunrise, will give the best results because the lighting in the forest is low and directional. As you can see, in this image I made use of backlighting, which outlined the sides of the featured tree and highlighted its large size to make it stand out from the rest of the foliage in the background.

Using a small f-stop allowed me to enhance the sharpness of the foreground ferns, for a pleasing lower border.

Postproduction

Three images were combined in Photomatix for the best detail in the highlight and shadow areas. In Nik Silver Efex, the Low Key 1 preset was used and the yellow filter was applied at 32 percent. A control point was added to the left of the tree to lighten the background and further show contrast between the big tree and the background. The image was moved into Photoshop where the Levels adjustment was applied to refine the blacks. Finally, the Brightness/Contrast tool was applied to adjust for printing.

▲ Three bracketed exposures were made: normal, –2 stops, and +2 stops. The normal exposure was 20 seconds at f/16.

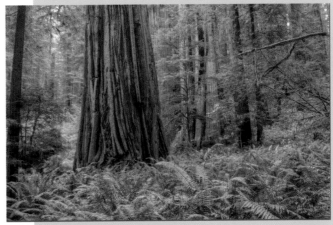

▲ Combined images in Photomatix.

▲ The image was converted to black & white in Nik Silver Efex.

Barren Rock

Abiquiu, NM (2014)

Shooting

The Southwest of the United States contains spectacular rocky landscapes. This location, photographed near dusk, presented mountains illuminated by the westward sun. The delicate intensities of the light highlighted the tones and shapes of the rocks. The clouds are shown in a moving state, as the wind at higher elevations was still significant. I had been climbing around these rocks for several hours, waiting for the magic moment when the sun would set and still provide light on the rocks. Much has been written about the so-called magic hours—those times of soft, directional lighting that occur early in the morning and late in the day. I shoot most of my images at these times of day, and I am never disappointed with the results that are achieved.

▲ Five bracketed exposures were taken for this image: normal, –2 stops, –1 stop, +1 stops, and +2 stop. The normal exposure was 1/40 second at f/11.

▲ Nik Silver Efex Pro.

Postproduction

This image was made from a combination of five bracketed images. Initially, the images were combined together in Photomatix using the Painterly preset with the Natural+ lighting adjustment.

Then, the resulting image was transferred to Nik Silver Efex for black & white conversion. In Nik, I used the High Structure (Smooth) preset along with several other adjustments, including the addition

▲ Photoshop Lighting Effects filter adjustment.

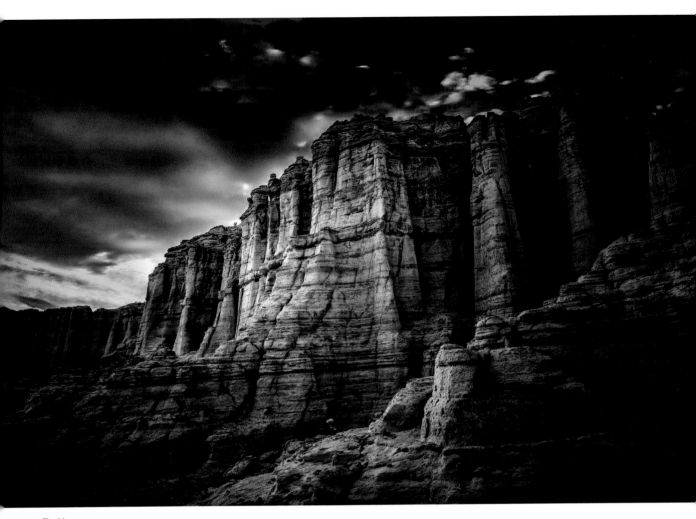

▲ Final image.

of two control points. One control point was placed in the center of the image to lighten the rocks; the other was positioned at the bottom right to darken the rocks. I adjusted the left slider to darken the midtones and used the right slider to brighten the highlights.

Next, I transferred the image to Photoshop, thinking the photo didn't capture the beauty of the lighting that was present when the photo was taken. I used the Lighting Effects filter to bring light to the center of the image and darken the surrounding mountains. I set the Intensity at 32 and the Ambiance at 15 for this image.

These numbers are included for reference but will vary considerably with each image and your personal taste. To finish the image, I adjusted the Brightness/Contrast. The Levels were also fine-tuned for printing.

66 I had been climbing around these rocks for several hours, waiting for the magic moment when the sun would set and still provide light on the rocks. 99

Tree Roots

Little Truckee River, CA (2012)

Shooting

I find the twists, curves, and gnarled formations of tree roots to be an intriguing subject for photography. Here, the exposed roots hanging over layers of rocks caught my attention. Specifically, this tree stood next to a river that seasonally covered the roots with water—only to ebb away, leaving the system bare and exposed.

Postproduction

The three bracketed exposures were combined together in Photomatix using the Balanced preset. The White Clip was lowered to retain additional detail in the lighter areas of the roots. In Nik Silver Efex, the High Structure (Smooth) preset was used to convert the image to black & white. Increasing the Structure setting to 42 percent and lowering the Shadows setting resulted in the rocks being darker against the roots. I further darkened the roots by moving the highlight slider to the left.

After closing Nik, the image was moved to Photoshop where I applied the Levels tool to further increase the dark value. Lastly, I adjusted the Brightness/Contrast to set the values for printing.

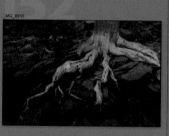
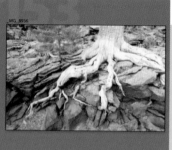

◀ Three bracketed exposures were taken: normal, –2 stops, and +2 stops. The normal exposure was .5 seconds at f/16.

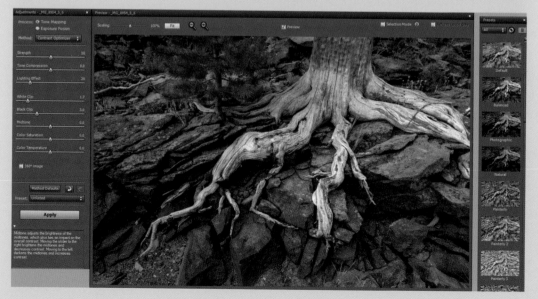

◀ The images were combined together in Photomatix with the Balanced preset. The White Clip was lowered to retain additional detail in the lighter areas of the roots.

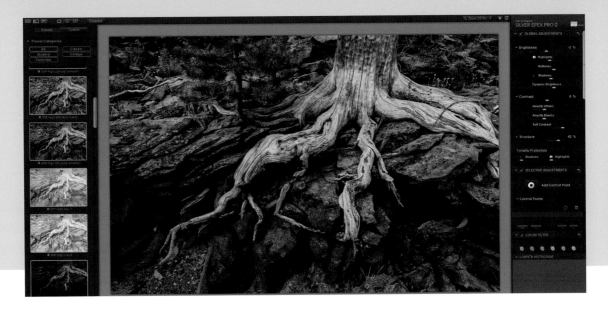

▶ Image converted to black & white using Nik Silver Efex.

Controls for Printing

I find an on-screen image highlight value of approximately 245 works best for my printing setup, ensuring the whites are at the proper density. Adjusting the whites in your image is important to create the most pleasing visual results before you print the picture. The accepted rule for image quality is for detail to be present in both the white and dark areas of your print.

▼ Final image.

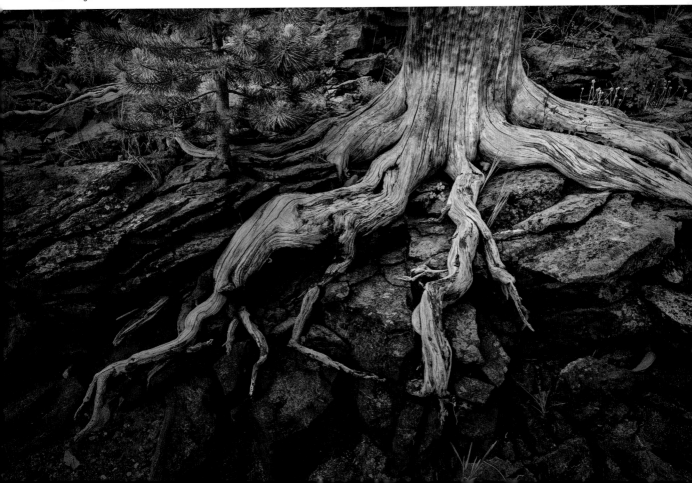

Bald Rock

Oroville, CA (2010)

Shooting

This photo was taken at Bald Rock Dome, near Oroville, CA. In this area, the many very large boulders scattered on the hillside make interesting subjects for black & white landscape photos. On the day I was there, I was fortunate to find abundant water pools and excellent reflections. The primary subject of this photo is the massive boulder in the center of the frame. The secondary subject is the reflection of the rock and the sky on the water. When taking photos, keep looking up and down, searching for secondary subjects and framing ideas to make your photos more interesting.

Postproduction

The three bracketed files were combined in Photomatix. The black & white conversion was completed in Photoshop using a Black & White adjustment layer with the Yellow Filter preset. The color channels were individually adjusted for the conversion, giving me a result that represented my vision and creativity. I often try all of the conversion presets to see if any of them produces an image that matches my vision. After the conversion, I adjusted the Brightness/Contrast settings and applied a Levels adjustment layer to refine the tones for printing.

◀ Three bracketed exposures were created: normal, –2 stops, and +2 stops. The normal exposure was 1/13 second at f/20.

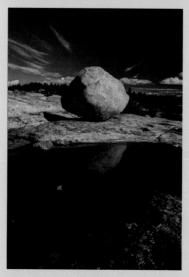
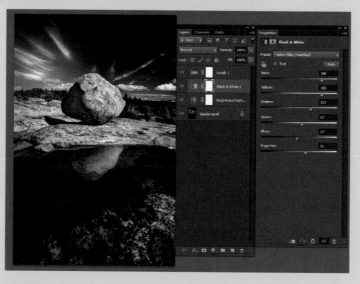

◀ *Far left:* The three files were combined in Photomatix.

◀ *Left:* Black & white conversion completed in Photoshop.

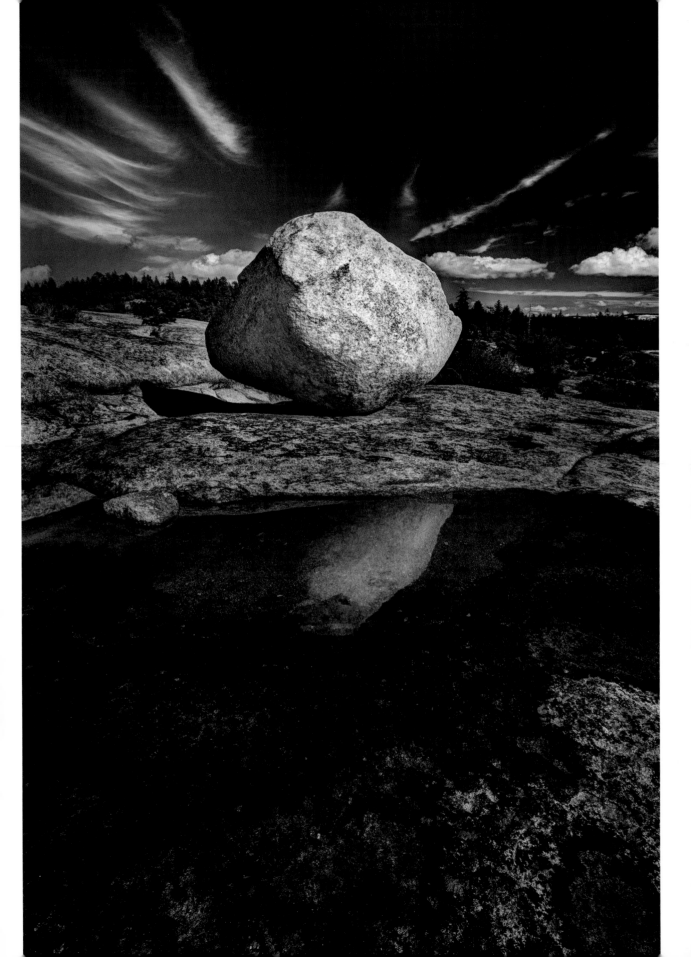

Foggy Trees

Northern California Coast (2014)

Shooting

Alder trees are common on the Northern California coast. They grow in stands and can be fragile during storms when their flexibility is tested with resultant bending and breakage. This group of alders had adapted to the force of nature, growing with curves and bending to survive. The image was taken with a downward

◄ Five bracketed exposures were taken: normal, −2 stops, −1 stop, +1 stop, and +2 stops. The normal exposure was 1/25 second at f/18.

◄ The images were combined using Photomatix with a Painterly Preset with a 4.4 Lighting adjustment.

◄ The black & white conversion completed using Photoshop.

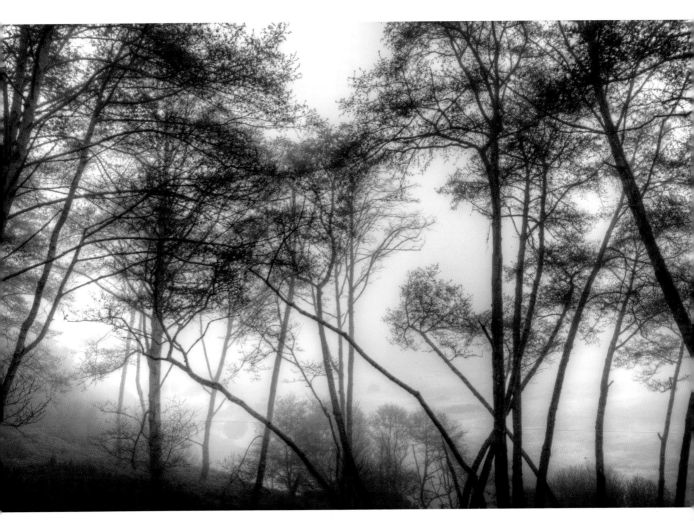

▲ The final image.

view at the coastal waters and the entire scene was covered with fog.

The even lighting and soft tones present in the scene were qualities I chose to preserve in my portrayal of the scene. In fact, the limited contrast range meant that a successful image might have been made using one normal exposure. However, I chose to use HDR processing for my final image of the scene.

Postproduction

The five bracketed exposures were combined using Photomatix with the Painterly preset and a Lighting adjustment of 4.4. I converted this image to black & white using a Photoshop Black & White adjustment layer with the Green Filter preset and high blue and cyan adjustments to keep the fog lighter in tone. In the final print, some contrast was added to the tree trunks, giving dimension to the scene. The borders of the image were darkened to maintain the center of the image view.

Since this scene is very common on the coast, I wanted it to be portrayed with a realistic look that people would recognize and easily relate to.

Fall Trees

Sierra Mountains, CA (2009)

Shooting

Fall color is spectacular in the Sierra mountains! Golden leafed trees sparkle and shimmer, compelling an image to be captured. Many images later, the spacing of the trees within this stand and the darkness behind them became my favored shot.

Postroduction

Three bracketed images were combined using Photomatix. The Painterly setting was used with the Normal+ lighting adjustment. The white point was lowered to give more detail in the highlights.

The image was converted to black & white using Nik Silver Efex, using the Normal preset with the Red Filter to darken the background. Then, I reduced the brightness of the midtones and shadows to further subdue the background. I also burned the edges on all sides to darken up the borders.

In Photoshop, the Levels tool was applied to darken the blacks. I used the Unsharp Mask filter to sharpen the image prior to printing.

Winter Trees

Chico, CA (2011)

Shooting

In winter, the bare trees reveal their true structure and majesty. Though I photograph trees year-round, I have an affinity for these stark forms. The trees in this photo are in a park close to my home. When looking for photos, don't overlook the street in front of your home or the park at the end of the road—and label these shots as "local." As things change in the years ahead, you and others may find that these images have greater personal value than images taken in another city or state.

Postproduction

Working from a single color exposure, I converted the image to black & white in Photoshop using an adjustment layer. I applied the High Contrast Red preset to darken the clouds in the sky. As there was limited color in this image, adjusting the color channel slider on the adjustment layer did not significantly change the majority of the tones. The blue in the sky was, however, altered by using the Red slider. Finally, the Brightness/Contrast and Levels tools were used to fine-tune the shot prior to printing.

Rock Vision

Oroville, CA (2010)

Shooting

While photographing rock formations and pools formed after a recent rain, I found the shape, tones, and sky reflections in this scene particularly compelling. It was a pleasant surprise that converting it to black & white made it even more intriguing. The final version of this photo was created from the color image, but it's considerably different from the original. This part of the process is particularly satisfying as it extends the art-making process.

Postproduction

I used a Black & White adjustment layer in Photoshop to perform the conversion. Adjusting the color sliders yielded a set of tones that matched my thoughts on what the final image should be. For example, the sky needed to be darkened, so I reduced the blue slider to –158. The exact amount of the reduction is a visual process that depends on how dark you want the sky to look.

I selected the center of the image, then created a Brightness/Contrast adjustment layer. This automatically produced a mask that let me reduce the brightness and increase the contrast in just that selected area. Another option for making local changes is to selectively use the Dodge and Burn tools on those parts that need to be adjusted. I use both processes but recommend the adjustment layer approach, since you can always return and readjust it if necessary. It gives you greater flexibility.

Finally, a few last overall adjustments with the Brightness/Contrast and Levels tools were made for final printing.

▼ Color image exposed at 1/10 second and f/20.

▼ Black & white conversion in Photoshop.

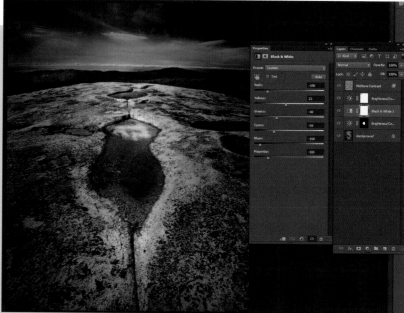

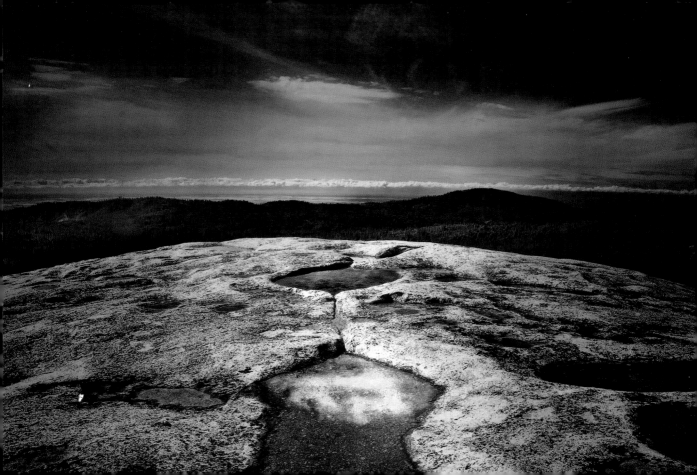

Tree in Park

Bath, England (2014)

Shooting

Surrounded by a lush green landscape dotted with majestic trees, I made this image at a park in the city of Bath, England. Beautiful trees and open grass areas are perfect surroundings for urban landscape photos. Regardless of the country, people have traditionally set aside land in urban areas to allow city-dwellers the pleasure of a natural setting. This tree was a perfect addition to the park. Strategically located, it added beauty and interest to the landscape and provided a focal point for photographers and nature enthusiasts alike.

Postproduction

I created this image from a single exposure shot without a tripod. In Photoshop, I converted it with a Black & White adjustment layer and the High Contrast Red preset; further adjustments were made with the green slider. Next, I used the Photoshop Lighting Effects filter to add brightness to the front of the tree and decrease the brightness in the remainder of the image. Additionally, I did some local dodging of the tree trunk to lighten it up a few tones. Finally, I used the Brightness/Contrast and Levels adjustments to prepare the image for printing.

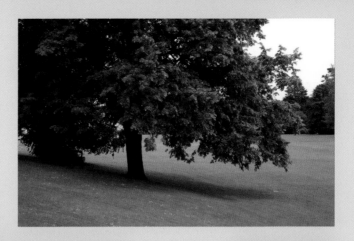

► The color image exposure was 1/125 second at f/14.

▼ *Top:* Black & white conversion using an adjustment layer in Photoshop.

▼ *Bottom:* I applied the Lighting Effects filter in Photoshop.

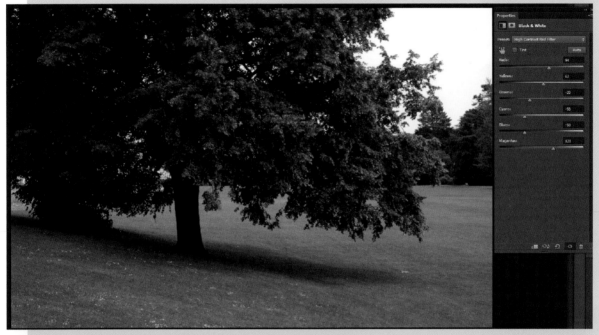

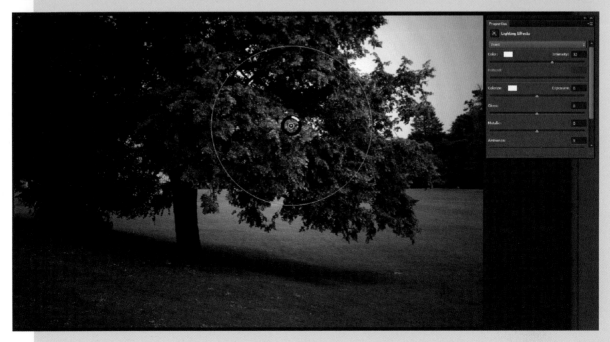

Yucca Plant

San Jose del Cabo, Mexico (2014)

Shooting

I was sitting in a restaurant in Mexico, waiting for my lunch, when I saw this plant near a side wall of the establishment. The colors of the green plant against the blue wall attracted me to the scene immediately. With an aperture setting of f/9, not all of the spines were in focus. Hand-holding the camera, I focused on the ones in the front, as they appeared to be most striking.

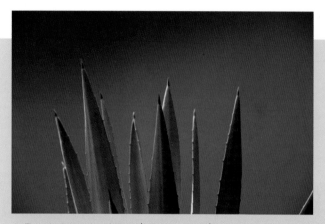

▲ The color image was shot at 1/250 second and f/9.

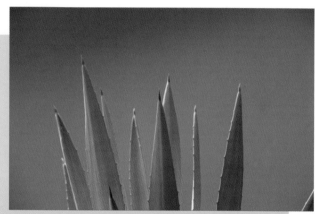

▲ Processed in Photomatix using the single image mode.

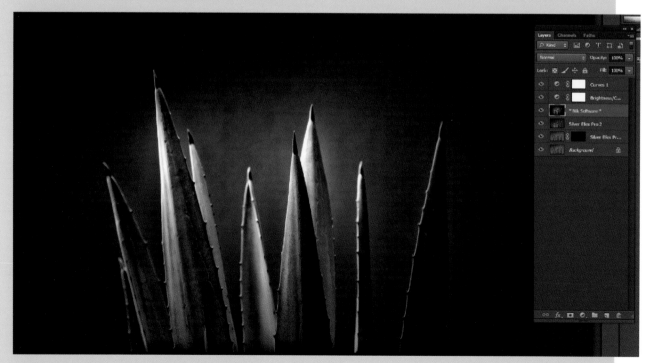

▲ The black & white view in Photoshop.

▲ Final image.

Postproduction

I used Photomatix to brighten up the colors and add some detail to the plant. While Photomatix is an HDR program intended to be used with multiple images, I have found that it also works well with a single image—if the image does not contain a long contrast range. Next, Nik Silver Efex was used to convert the image to black & white. Many preset options were available, but I chose Dynamic Smooth and lowered the blue Sensitivity slider by 50 percent, darkening the background. In Photoshop, I applied the Lighting Effects filter to enhance the center of the image and darken the outside areas. In the lower right corner of the image, a portion of the plant was present and distracting. This was removed, along with a line traveling across the upper left part of the image. Finally, I sharpened the image and used the Brightness/Contrast tool before printing.

Clearly, the black & white image was significantly enhanced from the original color image. The enhancement process is a rewarding part of the total image-making production as it allows a personal vision to be presented.

Three Trees in Fog

Chico, CA (2010)

Shooting

This image was shot on a foggy January afternoon in the Sierra foothills of Northern California. The foothills of California do not receive much snow in winter, but they get many days of dense fog. The fog adds an interesting and eerie effect to landscape photos. This afternoon, I was out specifically looking for objects in the fog and these three trees were particularly appealing. Adding to the subject was the boulder on the right and the filtered view of the trees in the background.

When shooting, I bracketed the exposures—but the end result was created using the one image with the +²/₃ stop exposure. I found the the normal and minus exposure to be underexposed, but the plus exposure was closer to normal on the camera's histogram. Many times,

▲ Three bracketed exposures were taken: normal, –2/3 stops, and +2/3 stops. The normal exposure was 1/20 second at f/16.

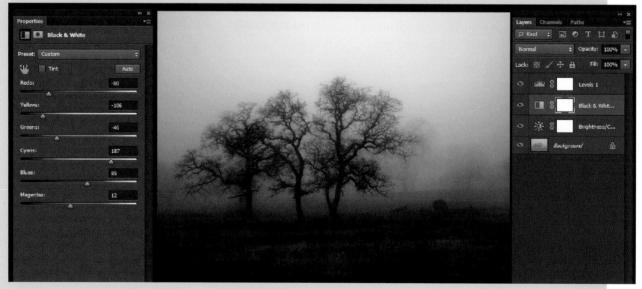

▲ Black & white conversion using Photoshop.

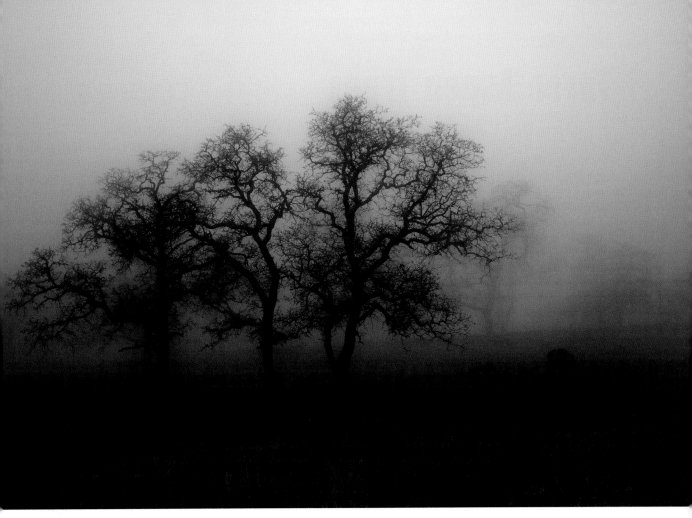

▲ Final image.

I find the camera's automatic exposure is close to perfect. In this case, though, the pale fog in the atmosphere confused the metering system. This is why shooting a bracketed sequence is a successful technique; in most cases, you will have at least one usable image.

Postproduction

Having chosen the overexposed shot to use as the basis for the final image, I opened it in Photoshop and made a Black & White adjustment layer. I experimented with using the preset color adjustments to make the image look acceptable, but this was unsuccessful. So, one by one, I moved the color sliders until I found the best combination.

In the screen shot on the facing page, you can review the color combinations I used—but don't look at these as magic numbers. Making black & white images is a personal process; you as the photographer must make the creative decisions.

The process used for this image was simple, as compared to many of my other images. Other methods could have been chosen to achieve the same result but this was my chosen approach and I found that the look it achieved matched the results I had envisioned.

Three Aspen Trees

Truckee, CA (2011)

Shooting

Aspen trees are prevalent in the Sierra Nevada Mountains. I have taken many photos of them in various locations, but I am always on the lookout for more. These trees look beautiful year-round, but in the fall their white bark and shimmering yellow leaves give them a breathtaking beauty. This group of three caught my attention, as did the soft side-lighting cast upon them from the morning sun. The lighting emphasized the roundness of the trunks and the texture of the bark. The dark background aided the image by defining the grouping of the three trees against the forest behind them.

Postproduction

I combined three bracketed images in Photomatix using the Enhanced Two preset with a reduction in the Strength, Compression, and Light effects. I reduced all of these sliders be-

▼ Final image.

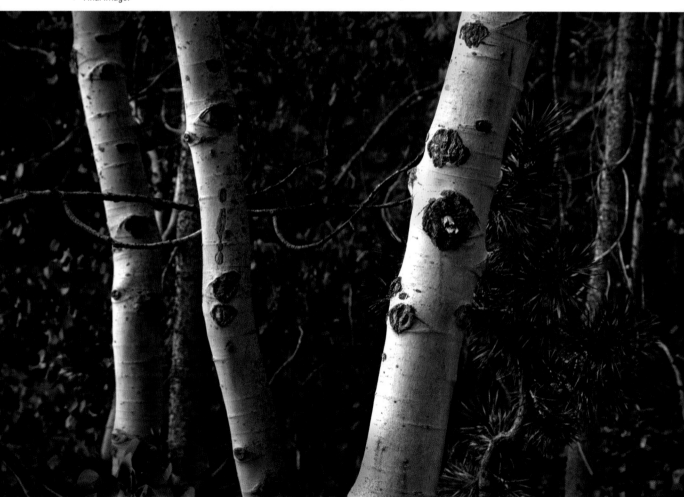

▲ Three bracketed exposures were taken: normal, –1 stop, and +1 stop. The normal exposure was 5 seconds at f/18.

▶ *Top:* Three images combined in Photomatix.

▶ *Bottom:* The black & white conversion in Photoshop.

66 From printing aspen trees in the past, I knew that if the white bark did not have adequate detail it would present as flat paper white. **99**

cause the preset made the background too dark and the bark too light. Next, I moved the image to Photoshop and created a Black & White adjustment layer. Using the Blue preset, I darkened the foliage and made the trees dominant in the foreground. I fine-tuned the Brightness/ Contrast and Levels, then applied sharpening. Finding that the white bark on the tree to the

right was still a bit light, I used the Burn tool set to Highlights at 4 percent to darken the white. From printing aspen trees in the past, I knew that if the white bark did not have adequate detail it would present as flat paper white. Significant whites and darks of a photo should always contain detail for proper viewing and reproduction.

Spiral Redwood Tree
Redwood National Park, CA (2014)

Shooting

I often take photos on the many Redwood National Park trails, which wind through these magnificent, giant trees. Their size and presence are breathtaking! The tree pictured here is particularly interesting due to the uncommon bark, which encircles the tree instead of running vertically. I was able to highlight both the bark and the size of the tree by pointing my 16–35mm wide-angle lens (set at 16mm) up the tree and including ferns in the foreground. The normal exposure in my bracketed sequence was 4 seconds at f/18.

Postproduction

In Photomatix, I combined five bracketed exposures (normal, –2 stops, –1 stop, +1 stop, and +2 stops). The contrast range of the redwood forest is large when the sky is included; having ±3 stop images might have produced a better image, but they were not available. Fortunately, the sun was not included, which helped maintain the overall range.

The image was then moved to Nik Silver Efex for black & white conversion. The Full Dynamic (Smooth) preset with yellow filter was added at 50 percent. When converting redwood trees to black & white, it is important to retain as much detail as possible in the tree bark. You can add contrast later in Photoshop, but lost detail cannot be restored. It is best to pick a conversion preset that retains the detail.

Finally, the image was moved to Photoshop to refine the Brightness/Contrast settings and sharpen the image for final viewing and printing.

◀ *Top:* Combined in Photomatix with the Natural preset.

◀ *Bottom:* Black & white conversion using Nik Silver Efex with the Full Dynamic (Smooth) preset.

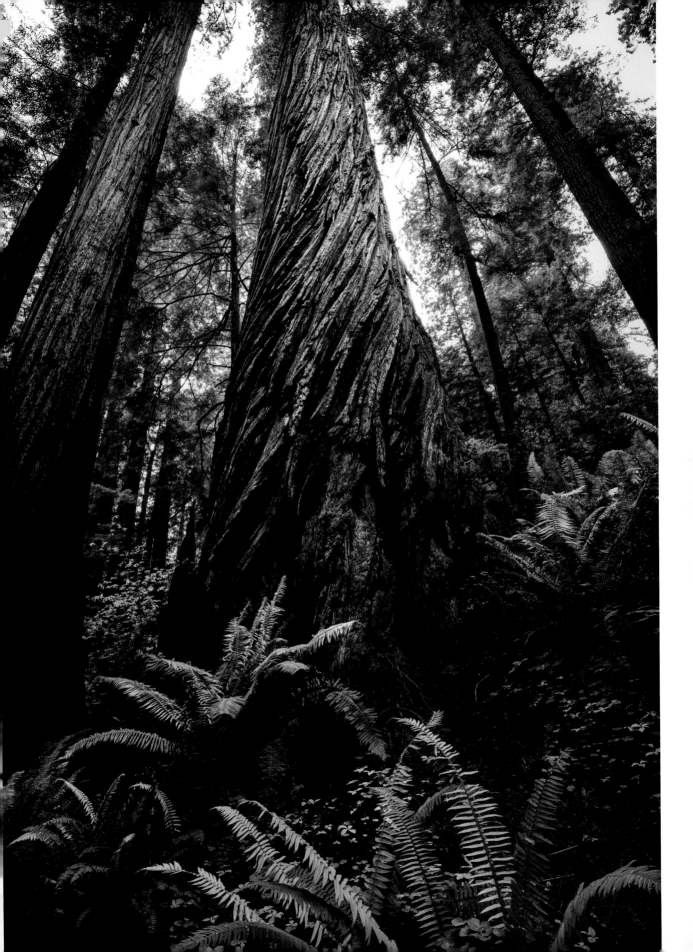

Single Tree and Sky

Panama City, Panama (2014)

Shooting

This was a found image, created while traveling and looking for landscape scenes that worked with my style and aesthetics. Seeing this magnificent tree, I envisioned a black & white image of a single tree. As you can see in the color im-

age, there were other buildings in the scene, in addition to a large, crumbling wall next to the tree. I actually liked the wall, but it did not fit in with my creative vision for this image. Using the magic of Photoshop, the wall and buildings were replaced with sky. This type of manipula-

▲ Original color image.

▲ Photomatix Single image conversion.

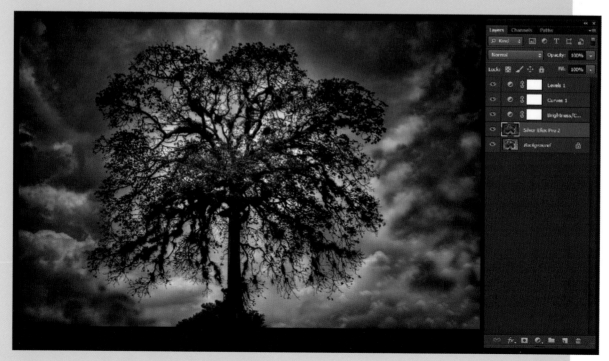
▲ Photoshop view using Nik Silver Efex for black & white conversion.

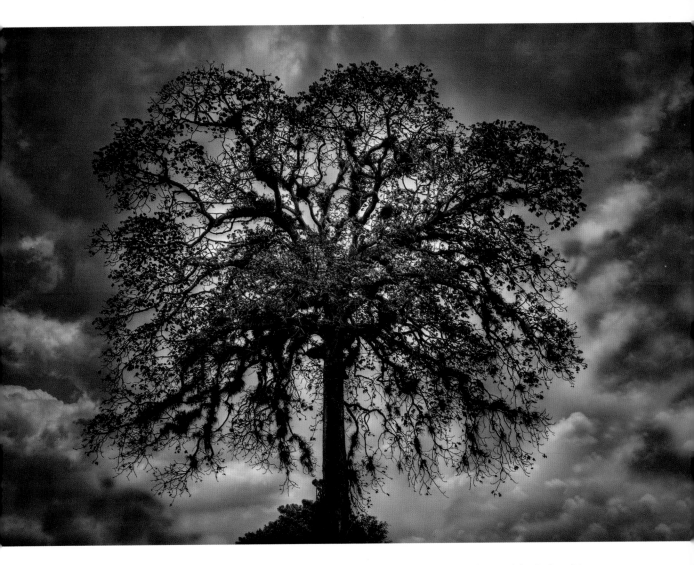

tion is beyond what I usually do in Photoshop, but in this case I considered it necessary. Many times, I ask myself this: If I were painting the scene, would I hesitate to make an adjustment? In this case, adjusting the scene was the way to make it match my artistic vision.

Postproduction

This image was made with a single exposure. In Photoshop, the buildings and stone wall were removed. The image was then adjusted in Photomatix, with an eye to retaining the maximum amount of highlights and shadow detail from the RAW image. Next, I opened the file in Nik Silver Efex and converted it to black & white using the default conversion. I then moved it back to Photoshop for contrast adjustments using the Curves tool. I also fine-tuned the Levels and Brightness/Contrast for printing.

Darken the Edges

Additional burning of the edges was needed to darken the light areas on the sides of the image. Most of my images are darkened around the borders to draw the viewer's eyes into the main subject matter. Removing light or bright spots on the borders of the image accomplishes the same goal.

Rocks and Clouds

Abiquiu, NM (2014)

Shooting

I was at this location, near the home of Georgia O'Keefe, while attending a black & white photography workshop in Santa Fe. The workshop group had gone out to take photos in the evening as the light was setting to the west. The rocks were magnificent and the clouds and sky made them look very dramatic. I shot my usual

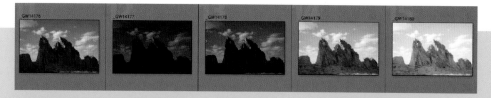

◀ Five bracketed exposures were taken: normal, −2 stops, −1 stop, +1 stop, and +2 stops. The exposure for the normal image was 1/60 second at f/9.0.

◀ Photomatix offers many choices for combining images.

◀ Nik Silver Efex was used to convert this image to black & white.

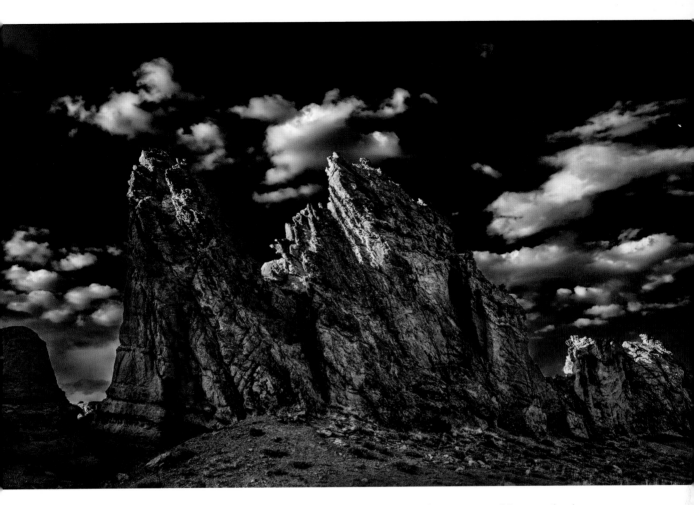

sequence of five images, making certain the details were captured. Framing the rocks allowed breathing room on all sides of the photo, giving a presence in the landscape.

Postproduction

The five bracketed exposures were combined in Photomatix Pro, which offers many choices for combining images. Some of the presets I use the most are Painterly, Default, and Vibrant. Other presets included with this program alter the image to a more significant degree than I find acceptable for the majority of my images. In this case, the Painterly preset was used and the Medium setting was used for lighting.

Had film been used for this image, I would have used a red filter to make the sky darker.

With a digital color camera, this same look can be captured quite simply by using Photoshop or Nik Silver Efex. In this case, I used the Nik software to convert the image to black & white. The Neutral preset was used with the Structure increased to 50 percent and I applied the red color filter at 127 percent to darken the sky— just as I would have with an on-camera filter in film days.

I finished the image in Photoshop, adjusting the Levels to enhance the blacks in the image. I applied the Unsharp Mask filter at 63 percent with a Radius setting of .7 and a Threshold of 1. Finally, I cropped the bottom of the image to eliminate the sunlight and the white edge on the right side.

Fallen Tree

Sierra Mountains, CA (2009)

Shooting

I am fascinated by the look of old, fallen trees as they decay and return to the earth. The tree becomes general lodging for all manner of flora and fauna that choose to reside and assist in the tree's breakdown, nourishing the earth as it disintegrates. The large portion of this tree shows extensive signs of decay, but it has many years to go before it finally vanishes into the ground. This image was taken standing above the base of the tree, using a 28mm focal length lens on my camera. As I wanted the entire tree to be in focus, I used the f/20 on my lens to maximize the depth of field. The lighting is soft on this image, which was taken early in the morning prior to sunrise.

Postproduction

A single color image I took of this tree was converted to black & white using a Black & White adjustment layer in Photoshop. The conversion was completely done by trial and error; I moved each color slider back and forth to determine how the black & white image should look. The primary color of this image was the green of the grasses—so when making the conversion, the green tones were darkened, allowing the light tones of the tree to stand out. Finally, local dodging of the center of the tree made the bark a few tones lighter. I also adjusted the Brightness/Contrast and Levels settings to prepare the image for printing.

There are no exact rules on how to do a black & white conversion. The process requires you to explore your personal and creative vision. I suggest allowing yourself time to experiment with Photoshop, searching for the right tones as the color image is translated to black & white. Trying a few different things can afford surprising and unique results.

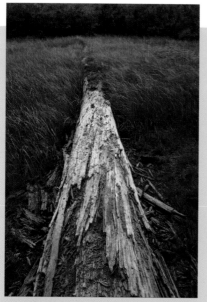

▲ Exposure at .3 seconds and f/20.

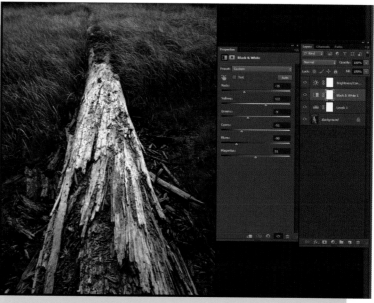

▲ Photoshop black & white conversion.

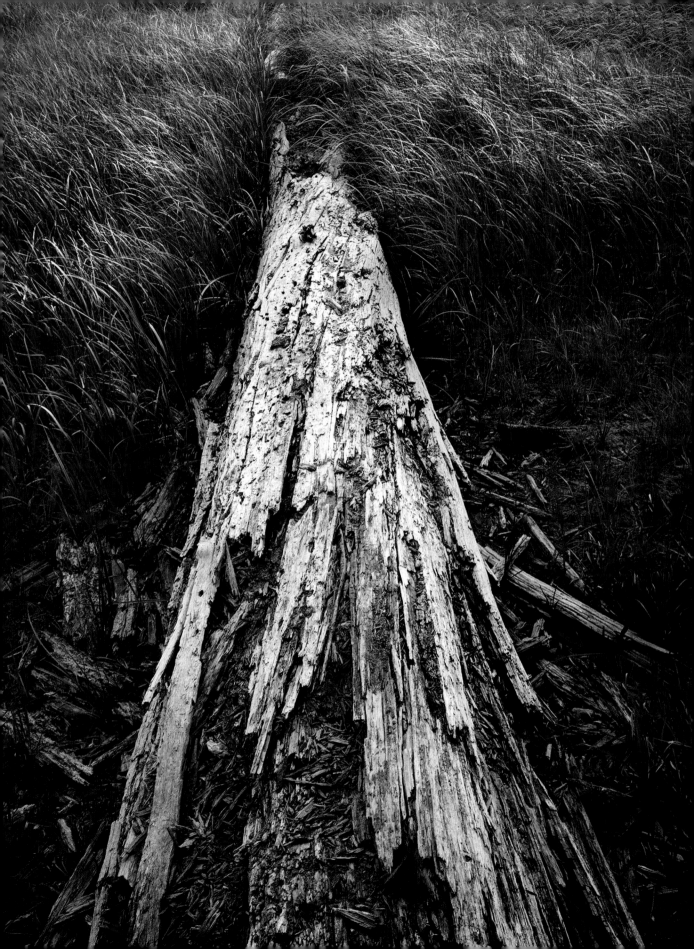

Light in the Redwoods

Redwood National Park, CA (2012)

Shooting

This photo was taken at the Redwood National Park in Northern California. By taking a bracketed set of five exposures, I fully captured the light coming into the forest from the back left of the image as well as the darkness of the

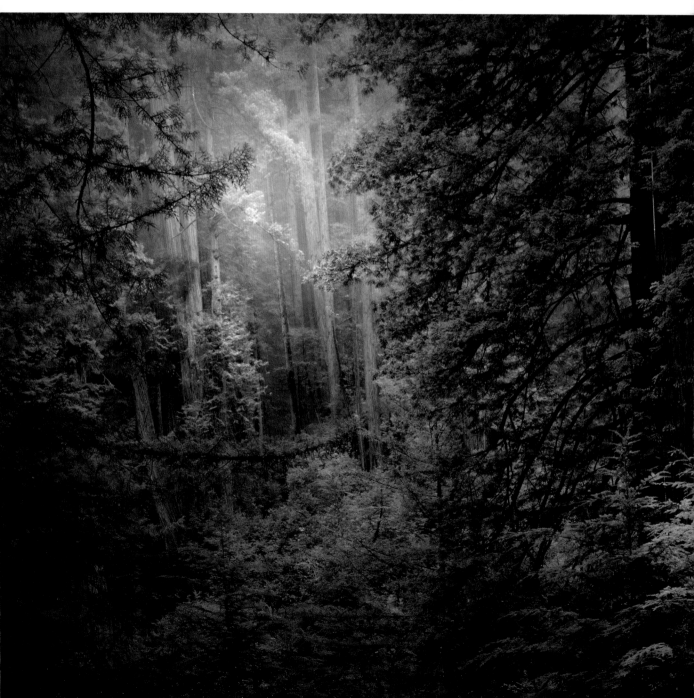

_DSC1753 _DSC1754 _DSC1755 _DSC1756 _DSC1757

▲ Five bracketed exposures were taken: normal, –2 stops, –1 stop, +1 stop, and +2 stops. The normal exposure was 5 seconds at f/18.

▼ Final image.

redwood bark in the upper right. What attracted me to the scene was the light from the back of the image; it was bright but muted as it streamed through the coastal fog that is prevalent in this part of the country. The trees on the right part of the image added to the power of the image. The juxtaposition of the large tree trunks and the smaller trees in the foreground is another factor that made for an excellent black & white redwood tree photo.

Postproduction

In Photomatix, I combined five bracketed images, using the Painterly preset with the Natural+ lighting adjustment. The black & white conversion for this image was done using Nik Silver Efex software and the Low Key 1 preset. A control point was also added to the background trees, further lightening the trees and enhancing the natural lighting present in the area. In Photoshop, the trees in the background were masked and further lightened. Contrast was also added to the area. Additionally, I dodged the foreground trees, brightening their appearance. Finally, a Levels adjustment refined the blacks and whites of the image for the final viewing and printing.

Emphasizing the beautiful natural light gave the final image a refined, ethereal quality. This process is very similar to what once would have been done in the darkroom with a cardboard dodging tool. Today, using software tools, I can achieve the same (and better!) corrections with far less testing and waste.

Surf and Rocks

Northern California Coast (2014)

Shooting

Surf and rocks are some of my preferred landscapes. For this image, I used long exposures (from 4 to 30 seconds) to make the water appear soft and mysterious. The lighting was intriguing, as there was a hilltop behind me that enabled the light from the rising sun to fall on the water farther out at sea while the foreground remained in shadow. The lighting created interesting patterns on the water that were further enhanced in Photomatix.

Postproduction

This image was made by using five bracketed exposures. In Photomatix, the images were combined with the Painterly preset and the Natural

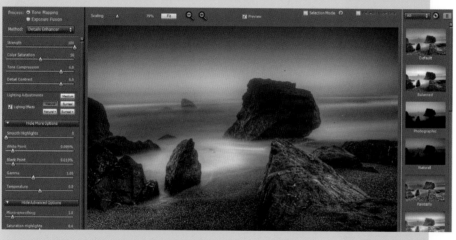

◄ Five bracketed exposures were taken: −2 stops, −1 stop, normal, +1 stop, and +2 stops. The normal exposure was 15 seconds at f/18. Notice that what should be the +2 exposure is actually the same as the +1 exposure. This is because the camera's longest shutter speed for auto-exposure bracketing is 30 seconds.

◄ Images combined using Photomatix with the Painterly preset with the Natural lighting adjustment.

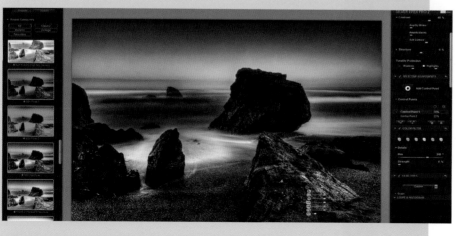
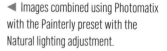

◄ black & white conversion using Nik Silver Efex with the Wet Rocks preset. Two control points were used to control density.

▲ Final image.

lighting adjustment was used. The images were converted to black & white using Nik Silver Efex and the Wet Rocks preset. Also, I applied two control points to the bottom of the image, darkening the large rocks on the right and the lower left corners. Next, I opened the image in Photoshop and used the Lighting Effects filter's Point setting to illuminate the center of the image and darken the surrounding parts. Continuing with the Dodge and Burn tools, the highlights were brightened on the center rock and darkened on the foreground rocks. Finally, I used Levels to create darker blacks, utilizing a setting of 4 by moving the left slider to the right. The Brightness/Contrast tool was used to fine-tune the image for printing.

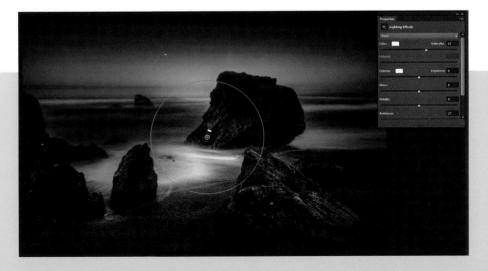

▶ Applying the Lighting filter in Photoshop.

Sunset Beach
Trinidad, CA (2012)

Shooting

Some of my most enjoyable moments have been on the beach taking photos as the sun was setting (that's my camera in the top right image, all set up on a tripod to take my bracketed exposure sequence). The landscape, the sounds of the surf, and the sun painting the sky with brilliant hues are often incomparable and, therefore, a favorite location for photography. Taking sunset photos can be challenging as the setting sun often confuses the camera's auto-exposure mode. Again, bracketing by 1 or 2 stops helps compensate and ensure you'll have at least one good exposure to work with.

▲ Photo of camera with image in preview.

▼ Final image.

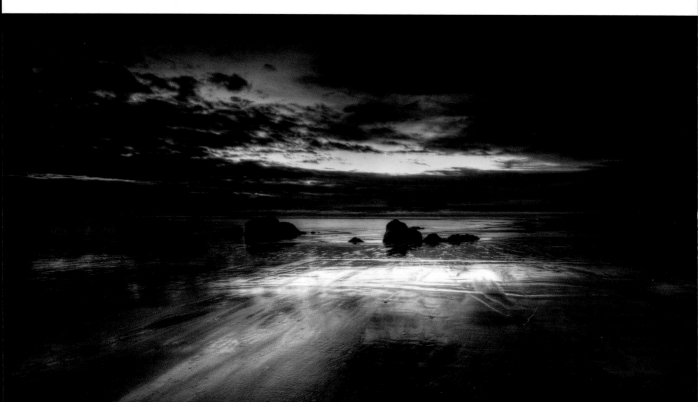

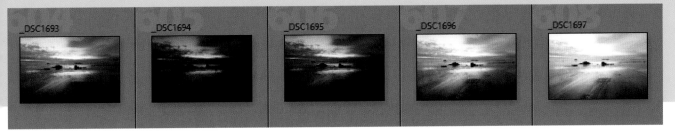

_DSC1693 _DSC1694 _DSC1695 _DSC1696 _DSC1697

▲ Five photos were taken for this image: normal, –2 stops, –1 stop, +1 stop, and +2 stops. The normal exposure was .6 seconds at f/18. This image was taken with a 16–35mm zoom at a focal length setting of 21mm.

Postproduction

This image was made with a series of five images with ±2 stops exposure settings. These images were transferred to Photomatix and combined using the Natural preset. I reduced the White Clip adjustment to 0 in order to hold additional detail in the bright sky and sand. Next, the image was opened in Nik Silver Efex and the Wet Rocks preset was used to convert the image to black & white. Finally, in Photoshop, further darkening to the upper sky helped draw the attention to the center of the photo. Additionally, adjustment using the Brightness/Contrast and Levels tools helped to refine the black and white points of the image. Sharpening was done for final printing.

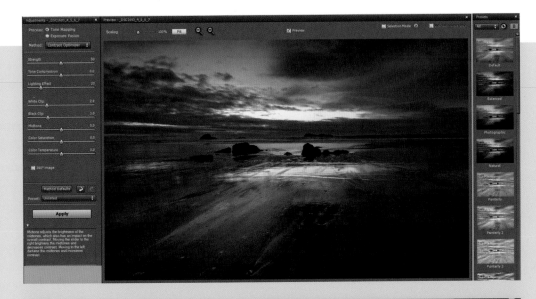

► Images combined in Photomatix using the Natural preset with the White Clip reduced.

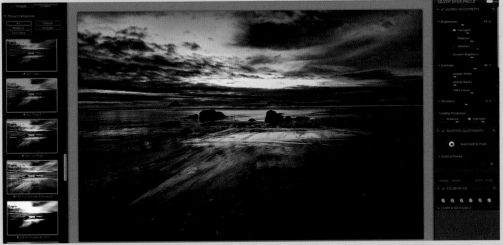

► Nik Silver Efex black & white conversion.

Storm Waves

North Coast at Patrick's Point State Park, CA (2014)

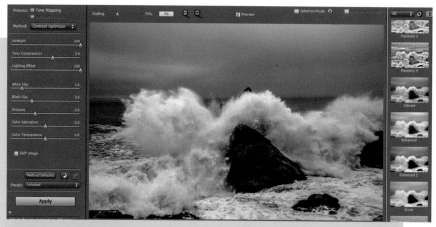

▲ Photomatix using the Vibrant preset.

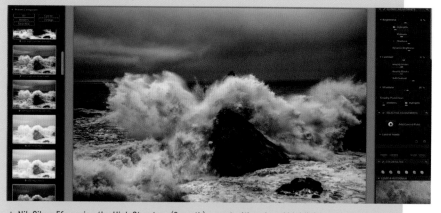

▲ Nik Silver Efex using the High Structure (Smooth) preset with reduced highlights and midtones.

▲ Photoshop adjustments.

Shooting

Ocean landscapes make for exciting photos. The sound and energy of the waves crashing against the rocks is awe inspiring. As I was photographing this image, the waves repeatedly cresting, one after another, were mesmerizing. The exposure on this image was $1/200$ second at f/9. A faster shutter speed was required to freeze the action of the waves.

I positioned myself several hundred feet back on a large rock with enough distance from the action that I didn't need to worry about the camera being splashed. Still, when taking ocean wave photos, you need to be mindful of the water spray and mist in the air that can attach to the camera lens. There are several ways to help lessen the issue, but none seem to resolve it completely. Some of the methods I use are: keeping the lens cap on the camera except when the actual exposure is being made, replacing the UV filter on the lens when it gets misty, and using a lens cloth to wipe

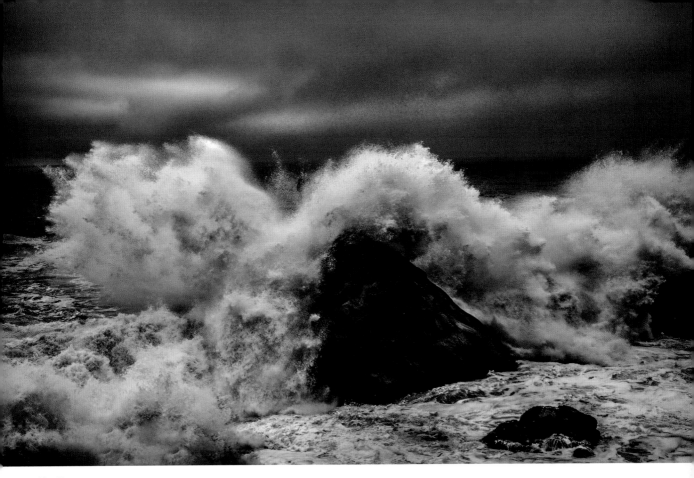

▲ Final image.

down the lens. I also like to cover the camera and lens with a towel when it's not being used. Another thing to try is a small ear dryer (used by swimmers to remove the water from their ears), which allows warm air to be blown onto the lens. Some of these methods work better than others—but one thing I have learned is that a misty lens, or one covered in water droplets, usually produces a photo that is difficult to retouch or unusable.

Postproduction

The image was adjusted in Photomatix to gain the maximum detail in the bright areas of the water and in the shadows of the rocks. Using the Vibrant preset enabled this adjustment.

Next, the image was converted to black & white using Nik Silver Efex and the High Structure (Smooth) preset. Reducing the Highlight and Midtone sliders enhanced the detail in the brightest parts of the image and darkened the midtones, creating additional contrast.

Finally, I used Photoshop to darken the borders of the image, remove the rocks in the lower left side, remove a rock jutting out in the center (near the horizon), and increase highlights on the rocks and sky. I also used the Rotate function to adjust the image .5 degrees clockwise, as the camera was not perfectly level when the shot was taken. Finally, I used adjustment layers to refine the Brightness/Contrast and Levels and fine-tune the image for printing.

Beach Grass

Trinidad, CA (2014)

Shooting

The waves in the sand, the light on the grass, and the fog in the background made this a perfect beach landscape photo. During a quest for ocean images, I initially chose the ocean and surf to the left of this frame as my subjects. When reviewing the images, however, the natural sand next to the water became a surprising favorite. This section of the beach is not visited frequently by beachgoers. During the morning of my visit, not another person was present, leaving the entire area available for taking photos. Hunting for special images may lead us in a forward direction—but, in this instance, the objects directly in front of the camera lens led to an unexpected and positive result.

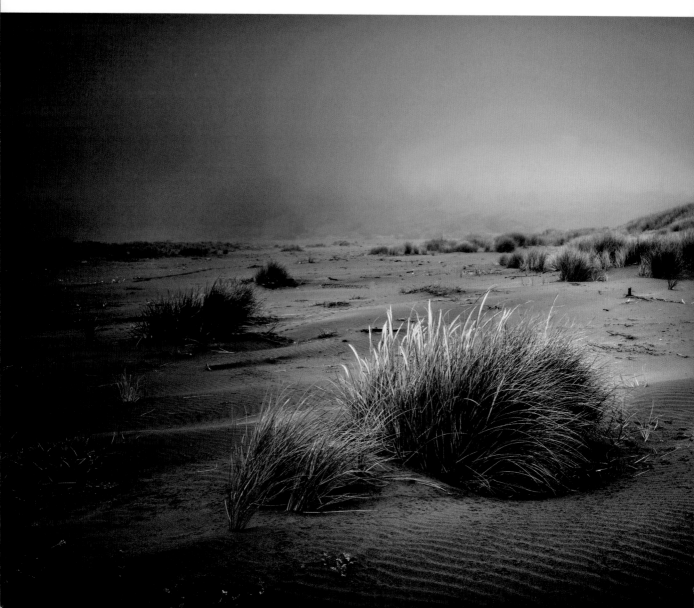

Postproduction

I combined the five bracketed images in Photomatix, using the Painterly preset. The Painterly preset is one I use frequently as it enables manipulation of the brightness of selective parts of the image through the application of lighting adjustment controls. Next, I converted the image to black & white using Nik Silver Efex and the Wet Rocks preset. In Photoshop, the grass tips were lightened and the edges were darkened. Finally, I used the Brightness/Contrast and Levels tools to fine-tune the image for printing.

▲ Five bracketed exposures were taken: normal, –2 stops, –1 stop, +1 stop, and +2 stops. The normal exposure was ¼ second at f/14.

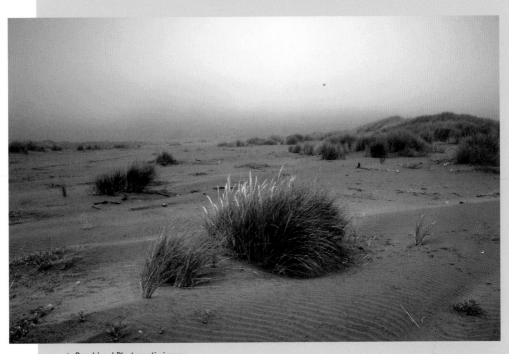

▲ Combined Photomatix image.

▲ Nik Silver Efex with Wet Rocks preset.

Rocks and Surf

Trinidad, CA (2012)

Shooting

The rocky shores of Northern California offer spectacular photo opportunities. If you want to capture water trailing across the sand, using the correct shutter speed is critical (here, it was 5 seconds at f/16). Determining what setting

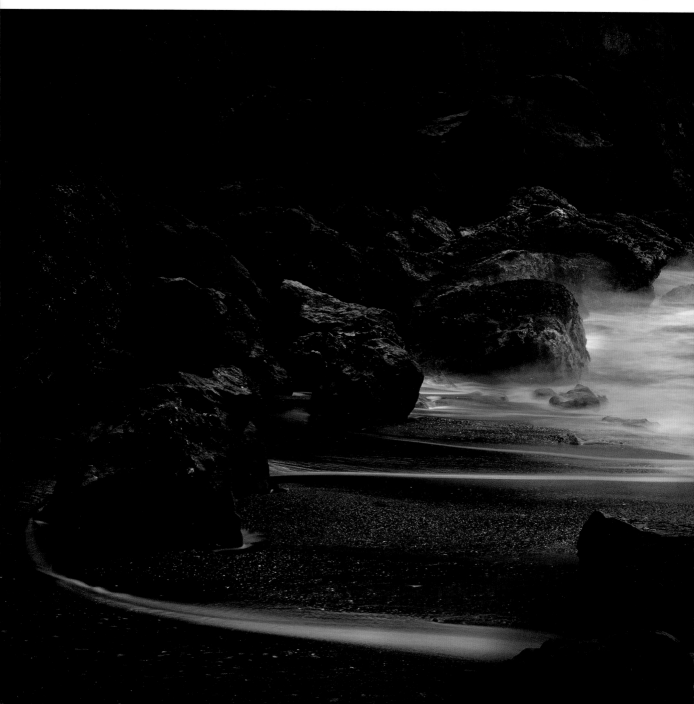

yields the best effect may require some experimentation. If you are bracketing, you can produce similar effects by combining multiple images shot at different shutter speeds.

Postproduction

The original file contained a bird in the center of the frame. I removed the bird in Photoshop because it presented a distraction rather than an attraction.

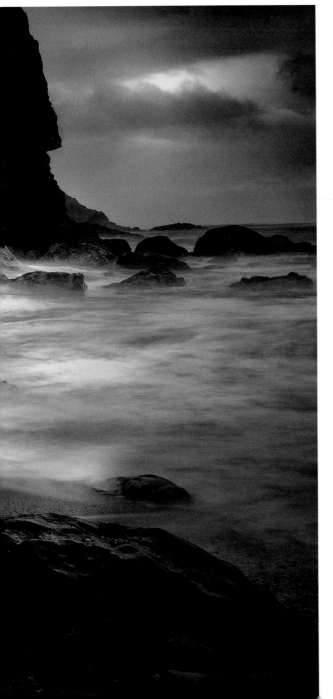

▲ A bird in the original capture was removed.

▲ Nik Silver Efex was used to convert to black & white.

▲ Using Photoshop for final adjustments.

I converted the image to black & white with Nik Silver Efex with the Neutral preset. Using two control points, I darkened the sky in the upper right and the rocks in the lower right with the Brightness slider.

The image was then moved back to Photoshop where several additional adjustments were made. The rocks in the upper left were lightened to show more detail. The water was minimally darkened, allowing for more detail to be seen. Finally, the sky was further darkened.

Sunset with Clouds

Caribbean Sea (2010)

Shooting

The image was taken off the coast of Jamaica from the deck of a cruise ship. Having taken several trips on cruise ships, I've learned to keep my camera with me. The seas in the Caribbean have spectacular sunrises and sunsets, as well as storms that may move through the area and add to the ambiance. In this image, the attraction was the variety of clouds in the sky and the backlighting by the lighter sky. When taking photos from ships, I raise the ISO up from my usual setting (100) to at least 400. This lets me use the faster shutter speeds needed to obtain images without blur from the motion of the

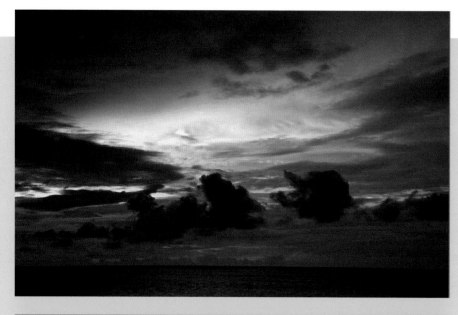

◄ Color image of sunset with clouds. The exposure for this image was 1/125 second at f/5.0.

◄ This image was converted to black & white using Photoshop.

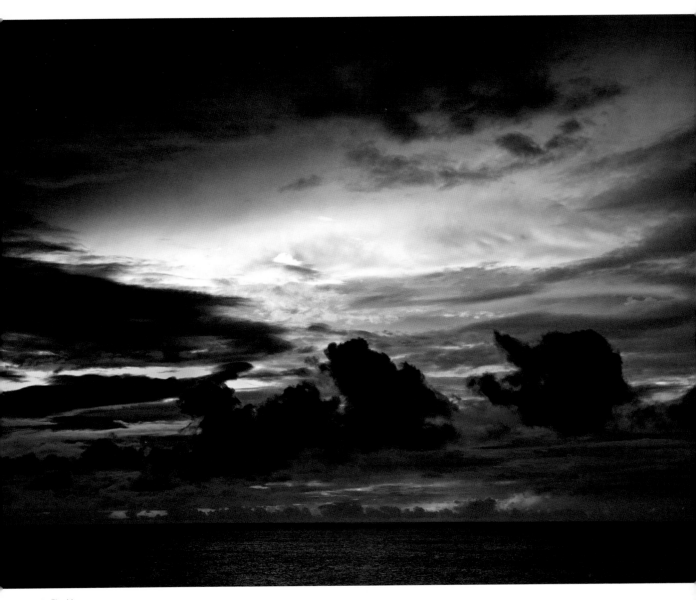

▲ Final image.

ship. I seldom take a tripod on a cruise; the ship's movement prevents creating a series of identically framed bracketed exposures to combine in an HDR process.

Postproduction

The color file was opened in Photoshop and adjustments were made to enhance the color of the sky. I applied the Levels tool to darken the dark clouds and lighten the brighter sections of the sky. I converted to black & white using an adjustment layer with the High Contrast Red filter preset. I also adjusted the color sliders until the image matched my vision for this scene.

Finally, I created a Brightness/Contrast adjustment layer and used it to fine-tune the whites and darks before sharpening the image for printing.

Pacific Coast at Sunrise

Trinidad, CA (2014)

Shooting

Scouting the beach before sunrise, a long line of clouds hanging over the coastal waters demanded my attention. I began by taking images of the clouds and water, but the digital preview of the images on my camera

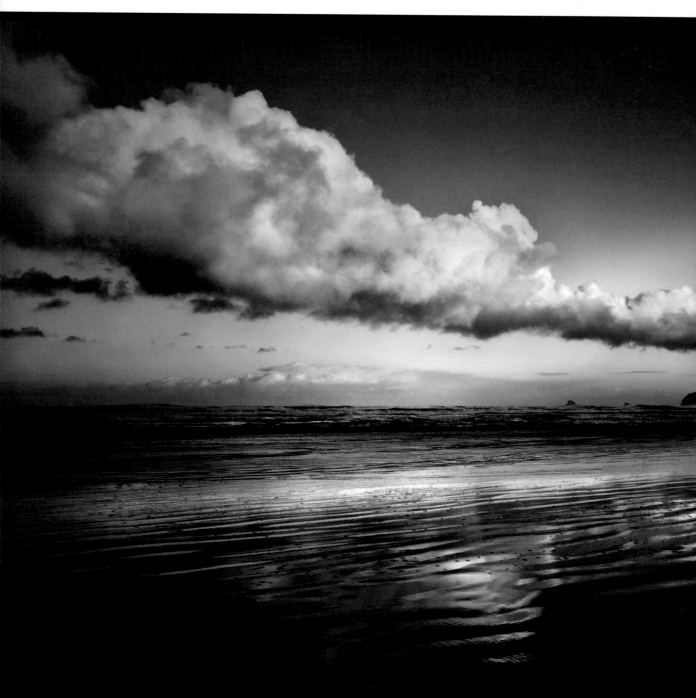

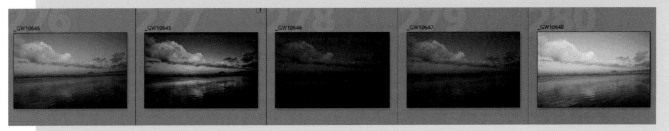

▲ Five bracketed exposures were taken: normal, –2 stops, –1 stop, +1 stop, and +2 stops.

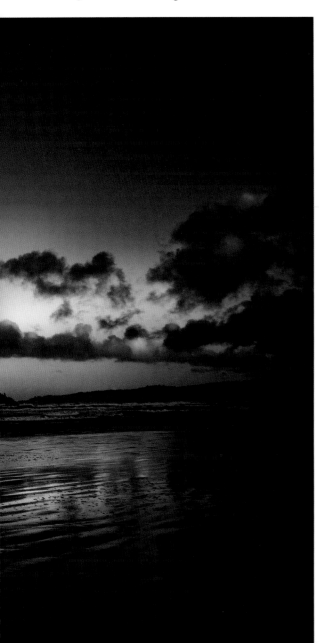

showed that the images lacked impact. Soon, however, the sun came up over the horizon in the east—and that same line of clouds came to life in the sky. The reflection on the sand and surf was perfect. I knew this was the image! The beautiful clouds and their reflections were elements not to be ignored. As usual, my shots were bracketed with five exposures that allowed me to capture all the details, from the brightness of the clouds to the darkness of the sand.

Postproduction

Initially, I combined the five images in Photomatix, but the results were not satisfactory. The clouds showed the effects of wind movement, so it was not the look I wanted. The final image was made by processing the normal exposure in Photomatix using the single image setting and the Painterly preset. I have used this setting on many images in the past and have been pleased with the results—as long as the contrast range in the image is not too large. If it is, then bracketed images really are needed.

Next, the image was opened in Nik Silver Efex and the Normal preset was used with a red filter adjustment to darken the blue in the sky.

Moving the image to Photoshop, I made adjustments to the Levels to darken the blacks and brighten the highlights. The foreground sand was also burned to further highlight the clouds and reflections.

Rocks with Surf

Trinidad, CA (2012)

Shooting

This image was taken in December on the Northern California coast. The time was early morning, while the light was still low. I shot a series of five bracketed images, with shutter speeds ranging from 1.6 to 25 seconds. Natural-

ly the waves kept moving as I shot the sequence, so when I combined the five exposures to create on final HDR image, I was also combining all those variations in the waves. This produces a smooth look that is similar to a long exposure of moving waves. The water has a painterly

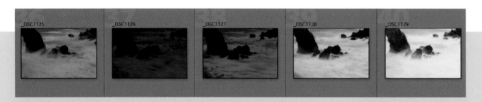

◀ Five bracketed exposures were taken: normal, –2 stops, –1 stop, +1 stop, and +2 stops. The normal exposure was 6 seconds at f/11.

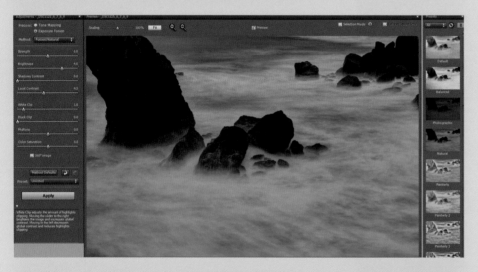

◀ Photomatix with Natural preset.

◀ Nik Silver Efex with High Structure (Smooth) preset.

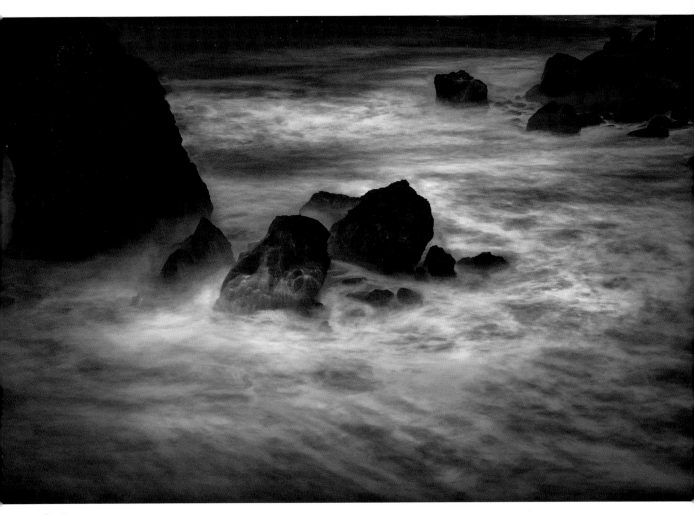

▲ Final image.

appearance, rather than a traditional photographic look. Digital photography and software gives us endless ways to convert our captures into final images that reflect our creative and imaginative abilities as photographers. This visual interpretation of the image has the added dimension of a personal, reactive moment that is captured by the camera and then presented in a way that reflects the artist's aesthetic.

Postproduction

This image was made from five bracketed exposures combined together in Photomatix using the Natural preset. The image was then transferred into Nik Photo Efex and the High Structure (Smooth) preset was used. No further adjustments were made in Nik, as the look of the image did not require further work.

Next, I moved the image to Photoshop and made an adjustment with the highlight slider on a Levels adjustment layer. This slider was moved to the left, brightening the whites considerably. The use of the black slider in Levels was unnecessary as the rocks were already very dark in the image. Finally, I adjusted the Brightness/Contrast to refine the white density to 245, which is a good density for the printer output.

Big Lagoon
Northern California (2014)

Shooting

There are several lagoons on the Northern California coast. These water bodies sit next to the ocean, separated by natural breakwaters for most of the year. During the winter, however, the breakwater is often breached and the fresh water of the lagoon combines with the salt water of the ocean. This image was taken in early

◄ Five bracketed exposures were taken: -2 stops, -1 stop, normal, +1 stop, and +2 stops. The normal exposure image was 1/20 second at f/13.

◄ The images were combined in Photomatix with the Monochrome preset with Natural lighting adjustment.

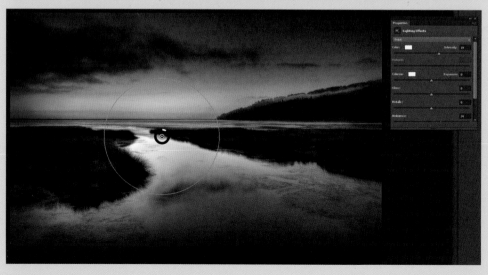

◄ In Photoshop, I applied the Lighting Effects filter.

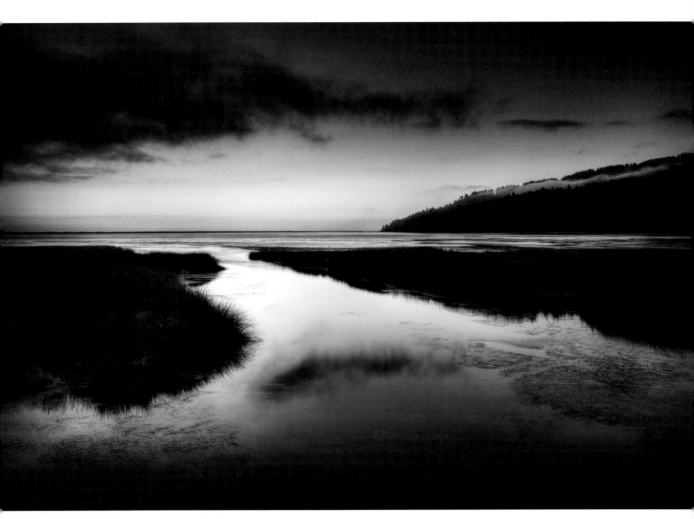

▲ Final image.

morning, prior to sunrise. My interest in the scene was the light reflections on the water and the clouds in the sky.

Postproduction

I made this image from a series of five bracketed images, processed using Photomatix. The black & white conversion was completed using the Monochrome preset with the Natural lighting adjustment. The image was then transferred to Photoshop where the Lighting Effects filter was used to brighten the center of the image and darken the outer edges. Considerable burning of the sky and water was also completed to adjust the tones, creating a look that matched my vision of the scene. Next, I used a Curves adjustment layer to increase the contrast of the image. Finally, I fine-tuned the Levels and Brightness/Contrast for final presentation and printing.

❝ My interest in the scene was the light reflections on the water and the clouds in the sky. ❞

Snow and Stream

Truckee, CA (2013)

Shooting

Snow can be magical—and soft pillows of wavy white snow with a gently flowing stream form the perfect subject material for large wall photographs or seasonal greeting cards. This image was taken after a January snowfall when the surface of the drifts was untouched and the trees had snow clinging to their branches. The

◄ Five images were taken for this photo: normal, -2 stops,-1 stop, +1 stop, +2 stops. The normal exposure was 1/25 of a second at f/18.

◄ Photomatix was used to combine the five bracketed images.

◄ Nik Silver Efex Pro was used for the conversion to black & white.

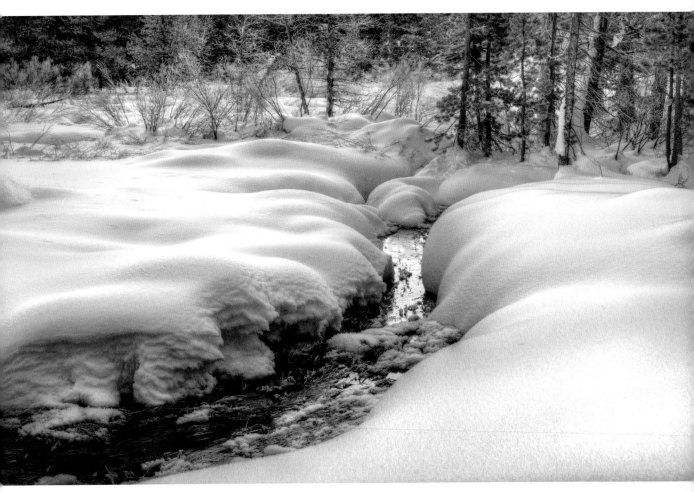

▲ Final image.

water running through the center of the image, especially with the light reflected in the center, further enhanced the photo.

Single-capture snow photos, even if shot to retain detail in the white tones, tend to lack the texture and delicate variations that can be captured by using HDR techniques. Therefore, I shot five exposure-bracketed images of this scene to give me the raw materials I'd need in postproduction.

Postproduction

I combined the bracketed images in Photomatix using the Painterly preset with the Natural+ lighting adjustment. The resulting image was converted to black & white using Nik Silver Efex with the Full Dynamic (Smooth) preset. The highlight density was increased by 21 percent, making the snow whiter.

In Photoshop, dodging was applied to brighten the center, making it lighter in tone. Next, I adjusted the Brightness/Contrast and Levels, fine-tuning the highlights and shadows for printing. I find snow brightness to be one of the most brightness-critical subjects to photograph. Snow needs to be seen with detail and texture but still remain white in density. It is simple to make snow appear too dark in a quest to show detail, but then it is viewed as less-than-pristine and unattractive.

Winter Lake

Donner Summit, CA (2014)

Shooting

Viewing this scene before sunrise, I knew that some magic was just waiting to happen as the light became brighter and the reflections on the water increased. I had photographed these trees several years prior, but never with partial ice on the lake and snow on the shore. During the winter months in the high Sierras, it's rare to find a lake that is partially covered in ice and has snow skirting the shore. Spring is the season that shows us landscapes in transition. Those transitions, with the reflections in the water and the ice still on the lake, are photographically compelling.

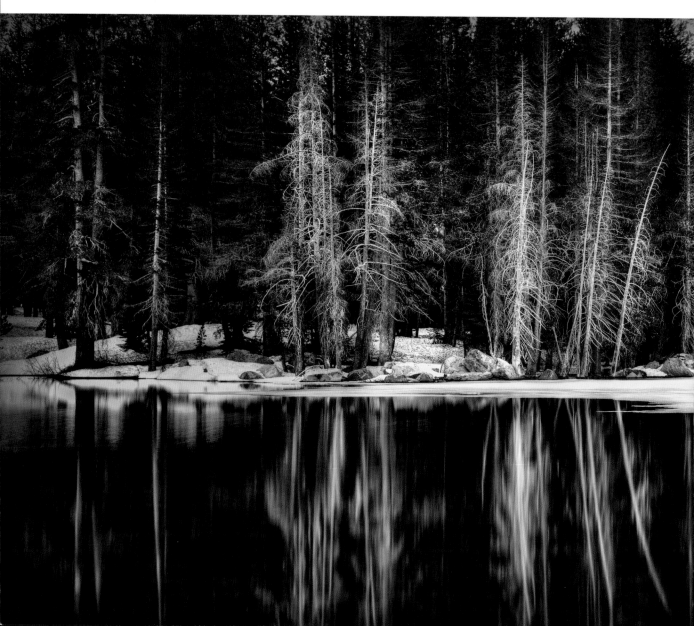

Postproduction

The five bracketed exposures taken were combined together in Photomatix, using the Painterly preset and the Medium light adjustment. The photo was then moved to Nik Silver Efex, where I applied the Neutral preset with a 50 percent increase in the Structure slider. The edges were also burned. In Photoshop, in Levels I increased the black with the dark slider and the highlights with the white slider. I used the Lighting Effects filter to brighten the center of the image and further darken the outer trees. Finally, a small amount of sharpening was applied with the Unsharp Mask filter.

66 Spring is the season that shows us landscapes in transition. Those transitions, with the reflections in the water and the ice still on the lake, are photographically compelling. 99

▲ Five images were taken: normal, -2 stops,-1 stop,+1 stop,+2 stops. The normal exposure was .5 seconds at f/13. The camera used for this image was Nikon 800E with a 28-300mm lens.

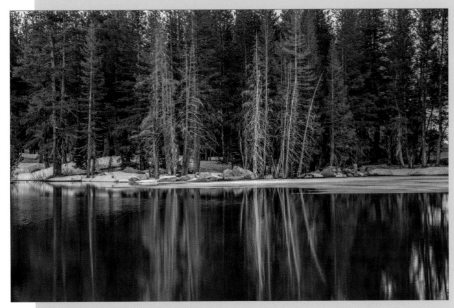

▲ Image after Photo Matrix.

Winter Trees with Snow

Sierra Mountains, CA (2009)

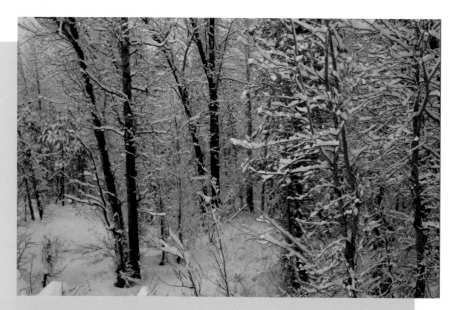

Shooting

The morning after a snow storm in the Sierra Mountains often produces ethereal scenes. The trees, precisely stacked with fresh snow, and the early light of day work together to make a magnificent snow image. Here, the prominent trees on the left side of the image became my focal point, adding depth to the image.

Postproduction

Due to the soft lighting and limited contrast range, I was able to use one photo to make the final image. I processed the image in Photomatix, using the single image setting and the Painterly preset with a Medium lighting adjustment. Next, I converted the image to black & white using Nik Silver Efex Pro with the Wet Rocks preset. Both the Painterly setting and Wet Rocks setting add texture

◄ *Top:* Color Image. The exposure for this image was, 1/160 of a second at f/14.

◄ *Center:* Photomatix, Painterly preset with Medium lighting adjustment.

◄ *Bottom:* Silver Efex Pro, Wet Rocks preset.

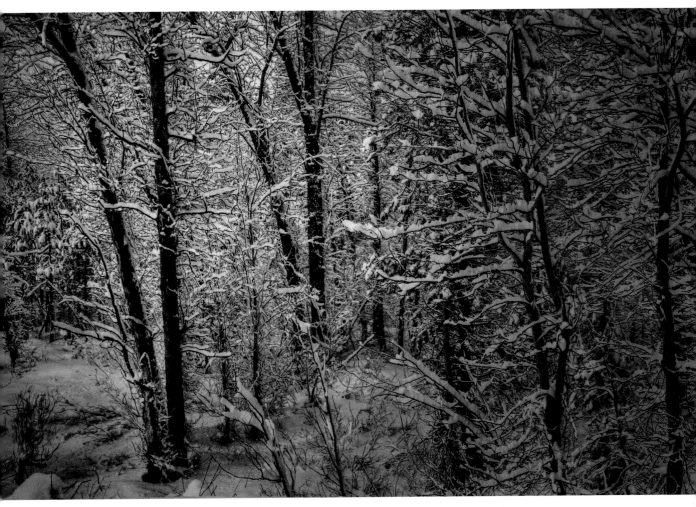

▲ Final image.

to the snow while maintaining an appearance of soft and recent snow. The next step was to bring the image into Photoshop and use the Lighting Effects filter to add brightness to the left side of the image, increasing the depth and highlighting of the trees. Finally, minor adjustments were made using the Brightness/Contrast tool to prepare the final image for printing.

▶ Photoshop, Render lighting.

Winter

Tree Trunk with Snow

Sierra Mountains, CA (2014)

Shooting

The texture and holes within the tree bark and the suggested movement in the snow, lying at the base of the tree, was a compelling sight.

One of the advantages of taking multiple bracketed exposures is that combining the images can give you increased texture and tone to your images. In the finished image, I still admire the

◀ Five bracketed exposures were taken: normal, –2 stops, –1 stop, +1 stop, and +2 stops. The normal exposure was 1/125 second at f/16.

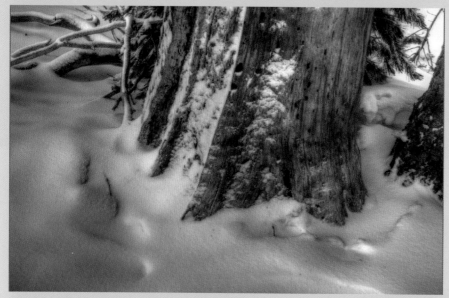

◀ The images were combined in Photomatix, using the Painterly Preset.

◀ I converted the image to black & white in Nik Silver Efex Pro, using the Wet Rocks preset with the Red Filter adjusted to 33 percent.

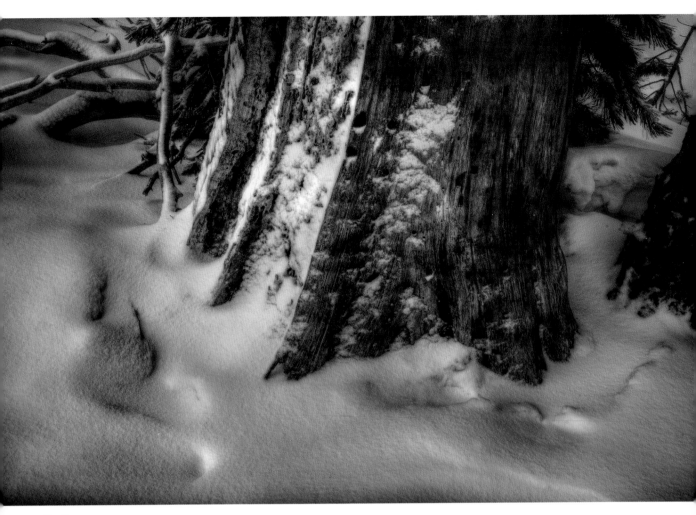

▲ Final image.

look of the snow on the tree and texture of the wood but the detail on the snow surrounding the tree continues to please me the most.

Postproduction

This image was made by combining five bracketed exposures in Photomatix with the Painterly preset. Next, the image was converted to black & white using Nik Silver Efex and the Wet Rocks preset. In Nik, a red filter was used to darken the wood tone of the tree and increase the contrast. The last step was to process the image in Photoshop, where considerable dodging of the snow around the tree lightened its appearance. The result was clean and white snow at its most appealing finish. Snow must appear fresh, bright, and light in tone to look its best.

> 66 The last step was to process the image in Photoshop, where considerable dodging of the snow around the tree lightened its appearance. 99

Rocks and Snow

Sierra Mountains, CA (2010)

Shooting

Winter snow and rocks in the Sierra Mountains create varied and interesting sights. This scene caught my attention because it held the illusion of a micro avalanche. The light that was

▶ The color Image exposure was made at 1/30 second and f/14.

▼ Final image.

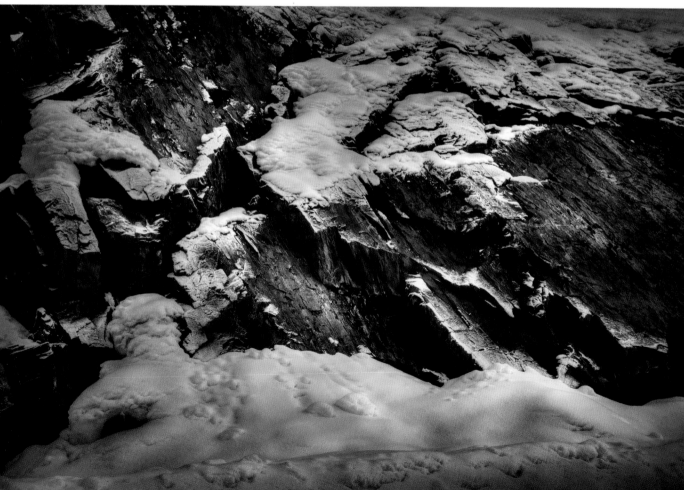

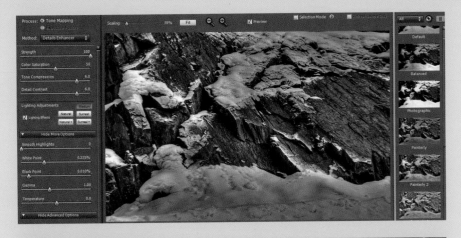

reflecting on the wet rocks and snow highlighted the already great contrast between the two subjects. This image was captured with a single exposure and the camera attached to a tripod. The tripod affords additional stability to the camera and allows the maximum sharpness for the image.

Postproduction

Made from a single exposure, this photo was processed with Photomatix using the Painterly preset and the medium lighting adjustment. Next, it was converted to black & white in Photoshop using a Black & White adjustment layer with the High Contrast Red preset and a reduction in the red channel to darken the rocks. The blue slider was raised to lighten the snow. Using the Lighting Effects filter, the Point Light tool brightened the rocks in three areas, enhancing the tones. Dodging and burning sections of the photo boosted

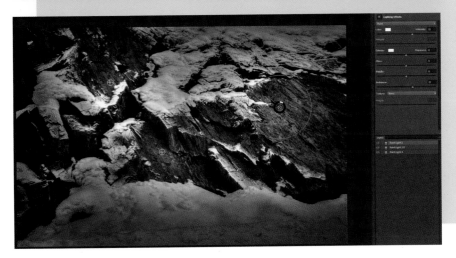

the texture of the rocks and snow. Finally, the Curves and Brightness/Contrast tools were used to enhance the contrast of the total scene and prepare the image for printing.

Mountain Snow with Trees

Donner Summit, CA (2014)

Shooting

2014 was a lean year for snow in the Sierra Mountains. This image was taken in February, and I didn't even need to use snowshoes. During a normal snow year in this location, snowfall may be six or more feet deep—covering half of the trees. I shot the image early in the morning, with the sun shining across the freshly fallen snow on the mountain side. Getting to this location requires significant effort, but it's well worth the results!

Postproduction

I combined five exposure-bracketed images in Photomatix using the Painterly preset with the Natural lighting adjustment. The file was

◀ Five bracketed exposures were taken for this image: normal, -2 stops, -1 stop, +1 stop, and +2 stops. The normal exposure was 1/40 second at f/18.

◀ Photomatix was used with the Painterly Preset and the Natural lighting adjustment.

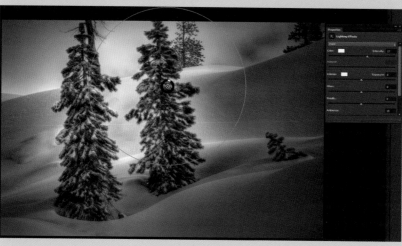

◀ Photoshop's Lighting Effects filter was applied, using two point light sources.

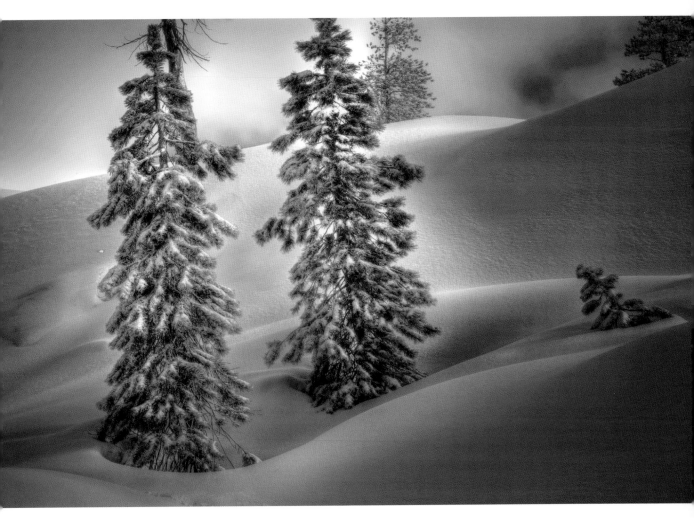

▲ Final image.

opened in Photoshop and the Lighting Effects filter was used to add two point light sources on the trees, giving them extra brilliance and detail. The image was then converted to black & white using a Black & White adjustment layer in Photoshop. The color channel sliders were adjusted to darken the sky and trees, and to retain the whiteness of the snow. Next, local dodging and burning of the snow was employed to give additional texture. Finally, adjustments to the Brightness/Contrast fine-tuned the image for printing.

▶ Converting the image to black & white with an adjustment layer in Photoshop.

Winter

Snow and Water

Truckee, CA (2010)

Shooting

Some of my favorite winter images are those that feature snow and water. To shoot this image, I set up my camera on a low bridge that gave me a nice viewpoint right over the river. What caught my attention was the reflection you see in the water from the trees near the river, along with the combination of snow, ice, and moving water. Putting all of these elements together in one scene improves the odds of taking a winning photograph.

▼ Final image.

Postproduction

Three exposure-bracketed images were taken of the scene and combined in Photomatix using the Vibrant preset. Some minor adjustments to the White Clip setting were also made, allowing for retention of detail in the light areas and snow. Next, the image was converted to black & white using Nik Silver Efex with the High Structure (Smooth) preset. This preset works well with snow, holding detail as needed but not giving it an extreme texture. The image was imported to Photoshop where the Lighting Effects filter added to the brightness in the center of the image. This was accomplished to

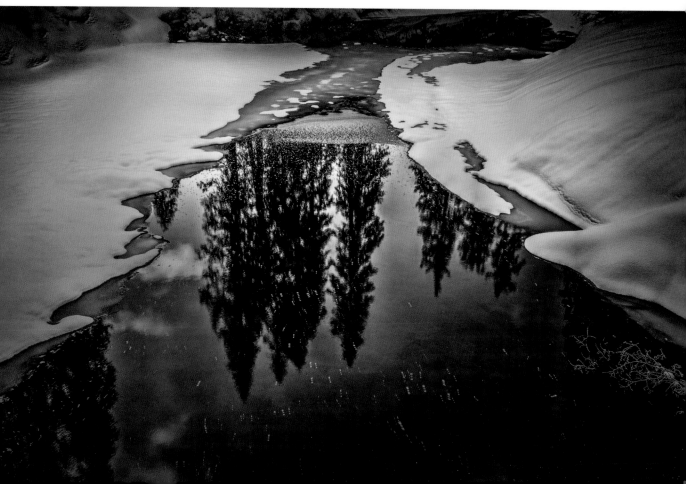

► *Top:* Three bracketed exposures were made: normal, –2/3 stops, and +2/3 stops. The normal exposure was 1/5 second at f/18.

► *Center (top):* The images were combined in Photomatix using the Vibrant preset.

► *Center (bottom):* Silver Efex Pro, with the High Structure (Smooth) preset, was used to convert the image to black & white.

► *Bottom:* Photoshop's Lighting Effects filter was used with two point light sources.

❝ I set up my camera on a low bridge that gave me a nice viewpoint from right over the water. ❞

further highlight the snow and trees and darken the surrounding edges of the image. Next, the Burn tool was used to further darken the bottom of the image and the Dodge tool was used to lighten the snow. Finally, the Levels and Brightness/Contrast tools were used for minor contrast adjustments, giving the image a bit more snap.

Bent Twig with Snow

Truckee, CA (2009)

Shooting

After the first snows of the season, ground foliage is commonly still present. This gives us the opportunity to photograph plants, rocks, and other natural ground cover that may later disappear under the layers of snow. In this case, the bend of the branch, and the snow hanging in clumps on the attached twigs, struck me as poignant. The light mottling the snow also gave it appealing depth and texture. When taking snow photos, carefully observing the light and its direction is an important factor. Cross lighting or backlighting often makes for successful images.

Extra Effort

In many areas, it can become physically difficult to photograph these images unless you are wearing skis or snowshoes. I have used snowshoes many times and can assure you that although travel is slow-going, it is steady—and your feet and legs do not sink with every step.

▼ Final image.

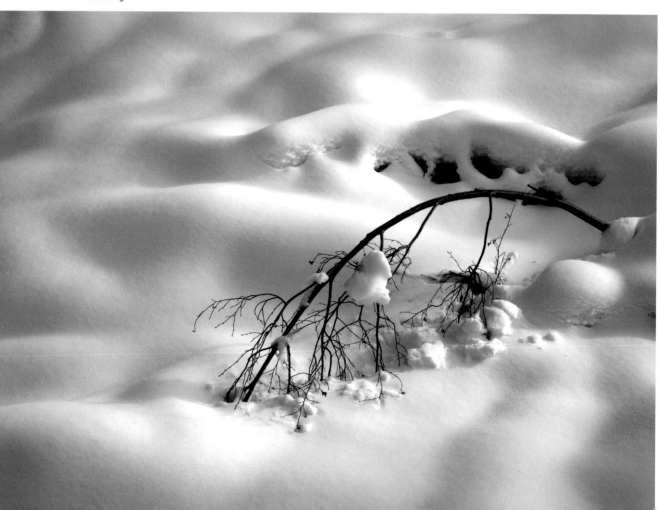

▶ Three exposure-bracketed images were taken: normal, –2 stops, and + 2 stops.

▶ Images combined in Photomatix using the Default preset and Normal lighting adjustments. I reduced the white point 50 percent to retain highlight detail on the snow.

▶ The black & white conversion was completed in Photoshop using an adjustment layer.

Postproduction

I combined three bracketed exposures in Photomatix using the Default preset with the Normal lighting adjustment. In Photoshop, I converted the image with a Black & White adjustment layer, adjusting the color sliders indi-vidually fine-tuned the scene to match my visual intent. I also increased the contrast to darken the blacks and applied the Unsharp Mask filter. A small amount of cropping was done to re-move the branch in the upper left portion of the original image and to enlarge the bent twig.

Lighthouse

Portland, ME (2014)

Shooting

Traveling on the East coast of America offers many engaging sights to photograph. The Portland Head Lighthouse is a good example. As the first lighthouse completed and put into service by the Federal government, under the Lighthouse Act of 1789, it is a captivating image. Touring the gift shop, I saw multiple images offered for sale of the lighthouse with spectacular waves and in winter scenes with snow and ice. I happened to be at the lighthouse on a beautiful day without a cloud in the sky—but the morning sun, shining brightly on the east side of the building, presented a photo opportunity that was not to be missed.

Postproduction

This photo was made from one normally exposed image. The first step was to process the image in Photomatix using the Default preset with the Natural+ lighting adjustment. Next, the image was converted into black & white using Nik Silver Efex and the Full Dynamic (Harsh) preset. I reduced the red slider to darken the roofs and adjusted the blue slider down to darken the sky.

In Photoshop, considerable burning was applied to enhance the lighthouse walls. Viewing the rocks at the bottom of the frame in the original color image, you can also see that I significantly darkened that area when creating the final image. The top of the lighthouse was also dodged, making it more prominent and adding to the glow of the light. Next, the fence at the bottom of the image was darkened, reducing its brightness. Finally, an adjustment to the Brightness/Contrast tool was used to complete the image for printing.

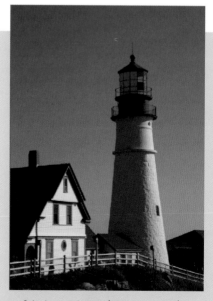

▲ Color image, shot at 1/400 second and f/13.

▲ Nik Silver Efex 2 with the Full Dynamic (Harsh) preset, red reduction to darken the roof, and blue reduction to darken the sky.

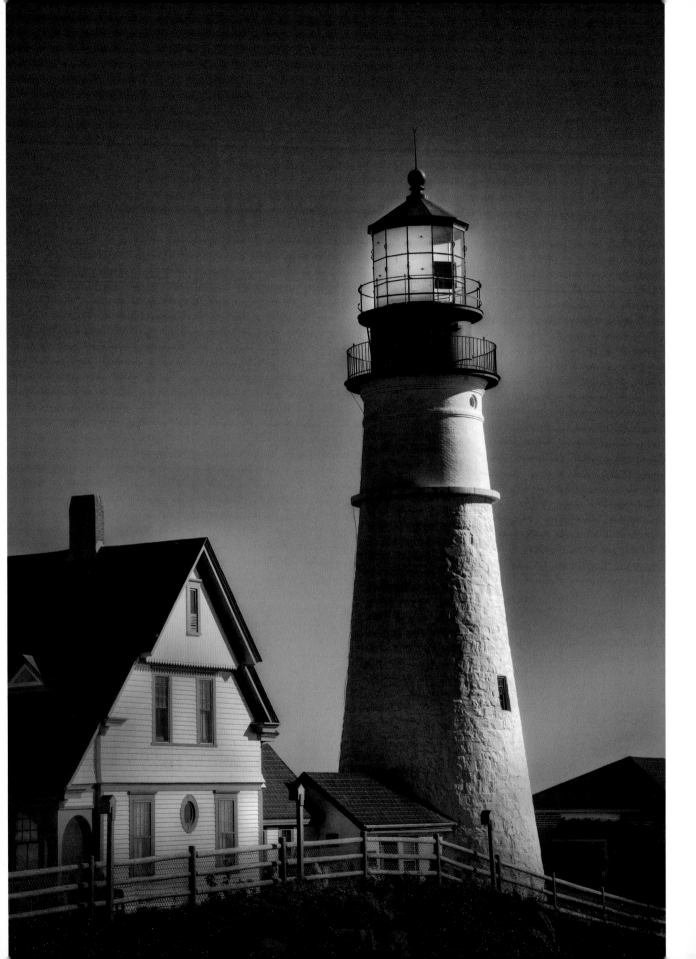

Man-Altered Landscapes

City Skyline

New York City, NY (2014)

Shooting

Photographing New York City from the top of the Empire State Building is an exciting expe-rience for a West Coast photographer. This day was perfect—there were clouds in the sky and only a short line of people waiting to go to the top of the building. I shot from all sides of the building, but my favorite view was looking south at the city with the Statue of Liberty in the middle right of the frame. A bracketed series of exposures would have been ideal, but tripods are not allowed—so I braced my camera against the railings to ensure the sharpest single captures possible.

Postproduction

The color image was processed in Pho-tomatix using the single image setting with the Painterly preset and Natural+ lighting adjustment. I converted to black & white using Nik Silver Efex with the Wet Rocks preset and the red filter setting at 146 percent. The filter was used to add contrast to the photo and darken the sky. In Photoshop, I applied the Lighting Effects filter (with the Ambiance setting at a low level) to

◀ *Top:* The color Image was shot at 1/100 second and f/11.

◀ *Center:* Image enhanced in Photomatix using the Painterly preset and Natural+ lighting adjustment. A white point reduction was used to hold detail in the white clouds.

◀ *Bottom:* I converted the image to black & white in Silver Efex Pro with the Wet Rocks preset and the Red filter at 146 percent.

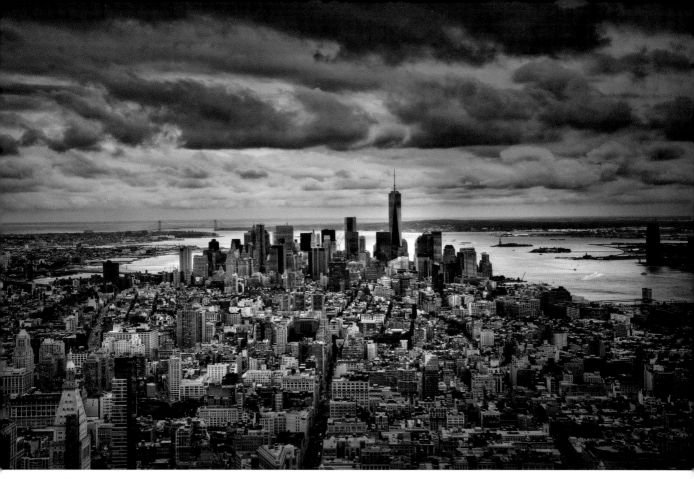

▲ Final image.

add light on the building in the center of the image and darken the sides of the frame. I also used the Burn tool to enhance the dark clouds. Additional dodging and burning were done to the buildings and water, enhancing their tones. Finally, the Brightness/Contrast tool was applied to fine-tune the overall tones of the image for printing.

What Makes It Special

I strive to take images that are unique to the area, but sometimes that is not possible. Over the decades, I'm sure that millions of people have taken photos of the city from the very spot where I was standing. However this image is special to me because it is the one *I* took—and the one *I* made into this black & white photo.

▶ In Photoshop, I used the Lighting Effects filter, adding three point light sources to brighten the buildings and darken the edges of the frame

Gold Hill

Shaftesbury, England (2013)

Shooting

Gold Hill is a well-known travel destination that has been photographed and painted for many decades—in fact, there were three other people taking pictures at the same time I was. While my image many not be unique, I doubt those other photographers' picture resemble mine. Making your travel images unique is often challenging but always worth the effort.

With no tripod available, I shot with a vibration reduction lens; this works well when hand-holding at slower shutter speeds ($^1/_{100}$ second at f/18). The street can also be photographed in the opposite direction. but I liked the left-to-right lines of the downward slope.

Postproduction

The image was converted to black & white in Nik Silver Efex using the Fine Art Process preset. Moving the color sensitivity sliders, I was able to attain a look that matched my vision for the scene. After the conversion, the image was opened in Photoshop for adjustments with the Brightness/Contrast tool. Some brightness was also added to the center of the field in the background, enhancing the area and adding to the image. I used Photoshop's Lighting Effects filter to achieve this effect.

Trying to keep the image as natural as possible can be challenging. Therefore, a light touch is recommended when altering photos.

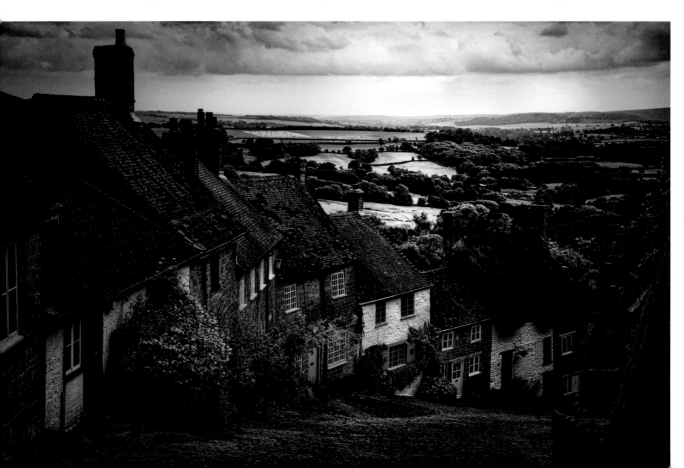

Golden Gate Bridge

San Francisco, CA (2010)

Shooting

The Golden Gate Bridge is a favorite of mine to photograph when in San Francisco. However, it's another major tourist attraction; there were a dozen other people photographing the bridge at the same time I was. Happily, the shifting fog constantly afforded new views. This image caught nearly the entire span of the bridge, with just the north end receding into fog.

Postproduction

I bracketed ±1 stop to ensure a good exposure, but this image was created from the normal frame. In Photoshop, I converted it using a Black & White adjustment layer and the Red Filter preset. Other minor adjustments, made using the color sliders, further enhanced the image's gray tones and afforded better reproduction of the image as a black & white print.

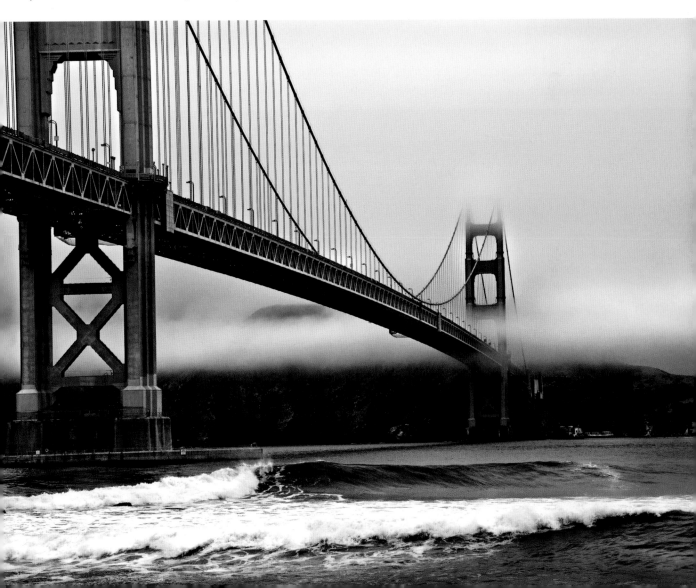

Rudy Patrick Seed Company

Kansas City, MO (2014)

Shooting

I have always had a fascination with exploring and taking photos of old structures, like this long-abandoned former seed company building. These artifacts reflect how we lived in years past. This building, although solidly made of brick, is in poor condition—with the window panels destroyed and the foliage reclaiming the land. The color image of the building is brighter than the finished black & white photo. I felt that this rendition better reflected the character of the scene.

Postproduction

This image was made from a series of five exposure-bracketed images combined together in Photomatix with the Painterly preset and the lighting adjustment set to Medium. Next, the image was converted to black & white using Topaz BW Effects 2 with the Low Key 1 preset. Topaz BW is not a program I use frequently, but I found the conversion worked well with this image. Next, I moved the image to Photoshop where the Lighting Effects filter was employed. With this adjustment, I added two

▼ Final image.

► Five bracketed exposures were combined in Photomatix.

► Topaz BW Effects 2 was used to convert the image to black & white.

► In Photoshop, I applied the Lighting Effects filter.

point light sources on the windows and in the center of the building. The areas around the windows were darkened using the Ambiance setting. Finally, adjustments to the Levels and the Brightness/Contrast fine-tuned the image for printing. Sharpening was also added at 50 percent—but this amount varies with the size of the print being made.

Fish Market

Marysville, CA (2011)

Shooting

Old buildings define how we lived in the past and are part of our cultural landscape. This business is reported to have been in operation from 1928 to 2004. Landscape photography not only includes the natural landscape but also landscape that has been altered by people. Decaying urban landscapes are particularly interesting, as they give information on how communities thrived and prospered in the past and how they evolved into the communities they are today.

This image was taken in the early morning, with unusual lighting on the front of the building. Although the high contrast of the light-

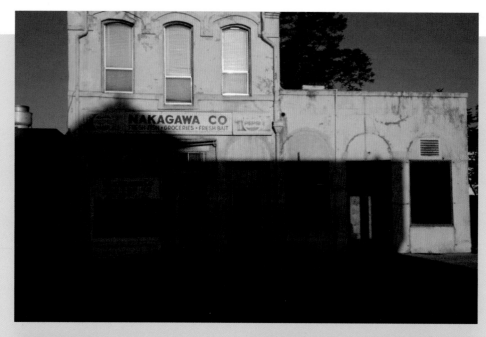

◄ The exposure for this color image was 1/160 second at f/22.

◄ The image was converted in Photoshop, using a Black & White adjustment layer.

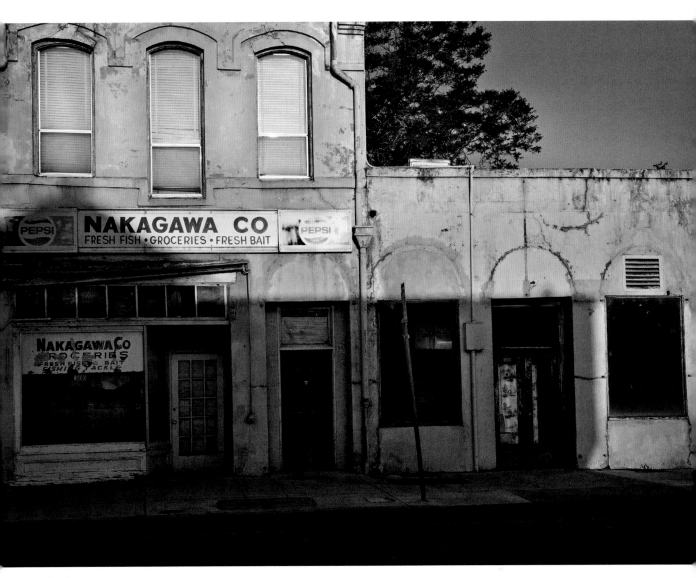

▲ Final image.

ing could have distracted from the structural appearance of the building, here I think it gave additional character and improved the dynamic of the photo.

Postproduction

This photo was made from one color image. It was taken from the opposite side of the street in front of the building. The black & white image was completed entirely in Photoshop. I started by adding a Black & White layer adjustment with the Yellow Filter preset and making additional color slider adjustments. This provided a greater separation of the tones. A Brightness/Contrast adjustment layer was added for the sign on the front of the building, darkening its brightness and adding contrast to the letters. Finally, the Brightness/Contrast and Levels tools were added for minor overall adjustments to prepare for printing.

Palm Tree

Miami, FL (2009)

Shooting

If you have traveled to South Beach neighborhood of Miami, FL, scenes like this may be familiar to you. The area is often crowded with tourists and residents walking and driving on the main boulevard. Being a photographer and at times a tourist, I found that the urban landscape in Miami offered fresh and unfamiliar photographic opportunities. The incorporation of plant life in the urban setting is of great interest to me. This tree, wedged between two buildings, left shadows on the wall behind it.

I took the image early in the morning, when the light was still low in the sky and provided

▼ Final image.

excellent cross lighting. I did not have a tripod, so I shot at a shutter speed of 1/200 second with the aperture at f/9.0. Switching to a higher shutter speed when hand-holding the camera will help minimize potential blurring from camera movement and keep your images looking sharp.

Postproduction

This image was made without complicated software manipulation. One image of the scene was opened in Photoshop. A Black & White adjustment layer was created and the High Contrast Red preset was applied. The sliders were adjusted to open up the dark areas of the palm branches, which the preset had darkened beyond visual impact.

I used a Curves adjustment layer to alter the overall contrast of the image. This is an excellent way to maximize your control when making contrast adjustments.

Finally, a Levels adjustment layer was used to deepen the blacks in the image. This was achieved by moving the left (shadow) slider to 5. On most images, I find that a setting in the range of 3 to 6 on the slider will supply the correct amount of blacks for the image. You can preview this effect by holding the Alt key while making the adjustments, viewing the areas of the photo that will be turned to black. Images with large shadow areas or very dark areas do not respond will to this technique; it makes them overly dark and lacking detail. The rule of thumb is that significant highlights and shadows of the image should contain detail. Small parts of the image without natural detail or significance can become pure black or white and go without detail. An example of this would be the inside of an auto tailpipe or a specular highlight on a window.

66 The rule of thumb is that significant highlights and shadows of the image should contain detail. 99

Window with Roses

Bath, England (2013)

Shooting

This photo was made while traveling in Bath, England. Old windows and doors with beautiful roses and other vegetation are a common sight in many areas of England. This image attracted me because of the placement of the rose vine around the window and the beautiful light shining on the glass and flowers. This scene looked beautiful in color and in black & white; it has an old world charm of yesteryear.

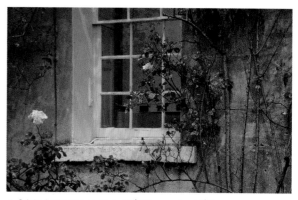

▲ Original color image, shot at 1/320 second and f/14.

Postproduction

The color image was converted to black & white in Nik Silver Efex using the High Structure (Smooth) preset with minor adjustments to the highlights and shadows for additional detail. In Photoshop, I adjusted the Levels and Brightness/Contrast. I used the Unsharp Mask filter to finalize the image.

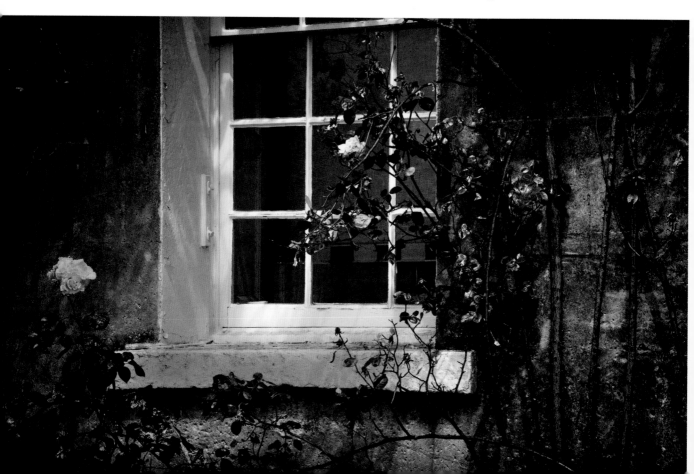

London Eye

London, England (2013)

Shooting

The London Eye is a popular and prominent attraction in London. The image I created was the result of applying several digital and software imagery applications. Approaching an image with this type of technique allows for an alternative presentation that exceeds the conventional expectations of traditional photography. Although some may consider it "overly digitized" in appearance, it's important to remember that similar styles of photography were accomplished with film over thirty years ago. At that time, the techniques were referred to as "darkroom magic." Today, the same magic can be accomplished using computer technology.

Postproduction

This image was made from a single image that was adjusted in Photomatix to highlight the clouds and darken the sky. Next, it was processed to black & white using Nik Silver Efex with the Film Noir 1 preset adjustment. This adjustment adds contrast, jagged edges, and black borders to the entire image. The final adjustments were made in Photoshop to remove black spots from the sky—detrimental flaws that were highlighted during the adjustment. The image was also lightened using a Brightness/ Contrast adjustment layer. I sharpened it using the Unsharp Mask filter.

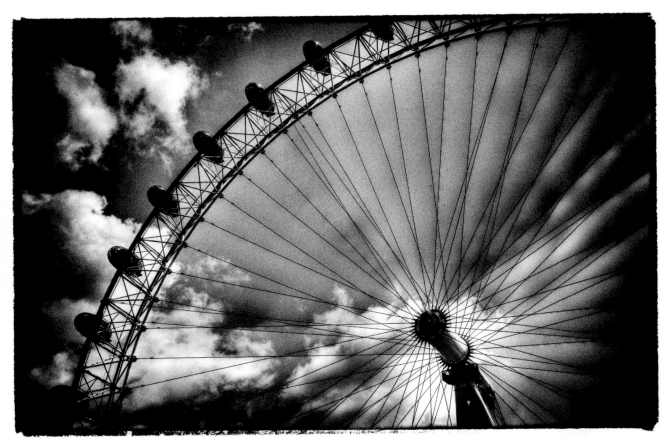

Donner Summit Bridge

Donner Summit, CA (2011)

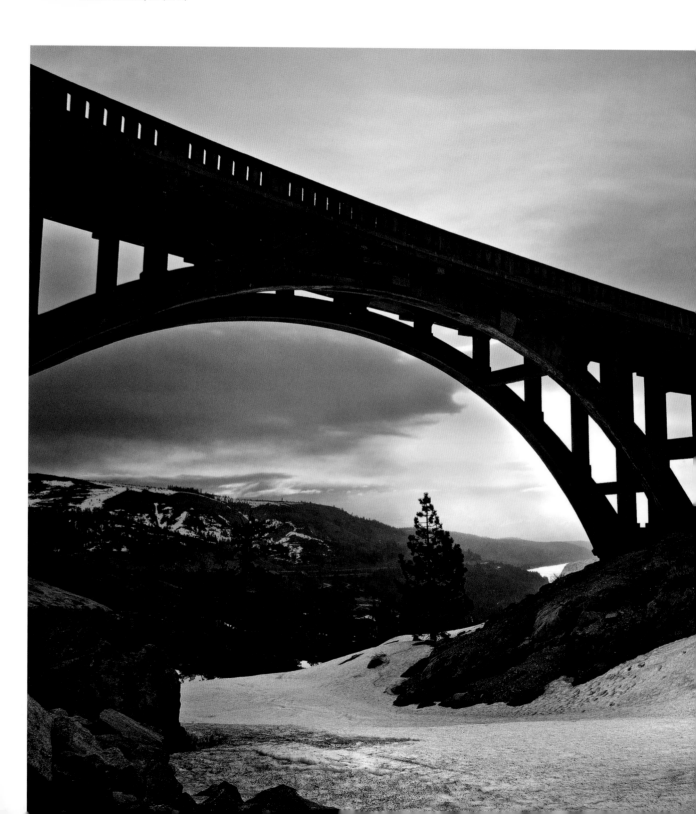

Shooting

Donner Pass Road in California is a favorite location of mine. The road begins near Donner Lake and winds up the side of the mountain, going over the bridge and, finally, connecting with Interstate 80. Off in the distance, Don-

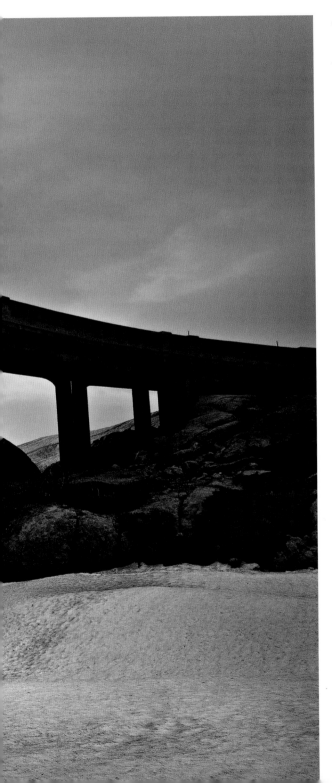

ner Lake can be seen with the early morning sunlight shining on it. For this image, I stood below the bridge in the snow, waiting for the rising sun to provide the magic moment. The vista was worth the wait.

Postproduction

This image required very little software manipulation. In Photoshop, I added a Black & White adjustment layer with the High Contrast Filter setting. Additional adjustment layers were made for Brightness/Contrast and Levels. I also sharpened the image. Finally, I burned the sky to hold detail in the brightest part of the image. Using the Burn tool on the highlights at 5 to 10 percent gently darkens highlight areas, eliminating a print with paper-white areas.

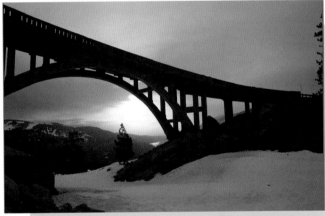

▲ The exposure for the color image was 1/25 second at f/22

▲ Black & White adjustment layer in Photoshop.

Park Bench Fall

Ashland, OR (2013)

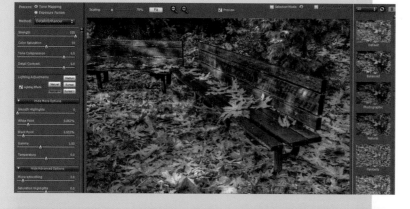

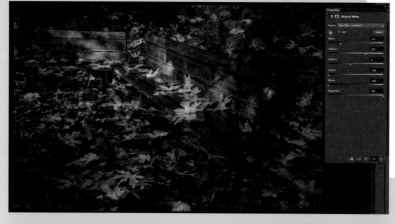

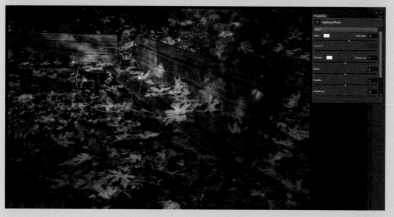

Shooting

Park benches blanketed in gold, orange, and red with hints of summer's end—it's a scene just about any photographer would find hard to resist. While it was easy enough to compose and shoot the color image, successfully converting the shot to black & white proved a challenge. It's a beautiful color image, as you can see in the images to the left—but in black & white, the gray bench and gray leaves initially fell flat. Not wanting to give up, I made more adjustments than usual to complete this image.

Postproduction

This image was made by combining five bracketed exposure in Photomatix. The Painterly preset with the Natural+ lighting adjustment was applied. Next, I converted the image to

◀ *Top:* Five bracketed exposures were taken for this image: normal, –2 stops, –1 stop, +1 stop, and +2 stops. The normal exposure was 1/3 second at f/13.

◀ *Center (top):* The images were combined in Photomatix with the Painterly preset and Natural+ lighting adjustment.

◀ *Center (bottom):* In Photoshop, I added a Black & White adjustment layer.

◀ *Bottom:* The Lighting Effects filter was applied in Photoshop.

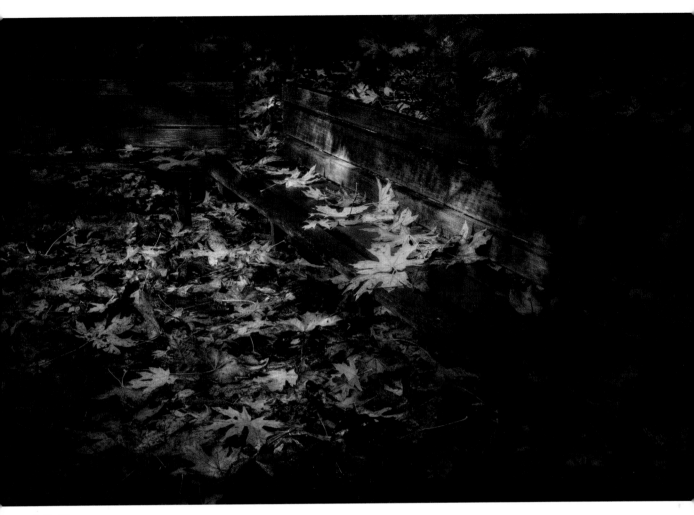

▲ Final image.

black & white in Photoshop. In order to get better separation between the bench and the leaves, I used the maximum amount of blue and cyan adjustment to darken the wood, and a minus adjustment on the yellow to lighten the leaves. Continuing in Photoshop, I applied the Lighting Effects filter to the center of the photo. This darkened the surrounding parts of the image. A strong application of this filter added drama and greatly enhanced the scene's look in black & white. Finally, many of the yellow leaves on the ground and on the bench were dodged, giving them additional dimension. The final

black & white image is a significant variation from the color image—but it was the preceding alterations that allowed for a successful and pleasing black & white photo to be printed.

❝ While it was easy enough to compose and shoot the color image, successfully converting the shot to black & white proved a challenge. ❞

Old Church

Santa Fe, NM (2014)

Shooting

New Mexico contains numerous old adobe structures that offer excellent subject material for photographers. This church, near Santa Fe, was built in the year 1880 and was the subject of a photograph by Ansel Adams in the 1960s. The church is now mostly abandoned, except for a small cemetery next to it.

For my image of this church, I decided to focus on the cross at the very top of the structure. There was amazing light as I shot in the early evening, and the clouds added to the presence of the building. The wind added some movement to the clouds, further enhancing the ambiance of the building and its location.

I used a high shutter speed ($^1/_{400}$ second) with this image because the wind was strong and there was a high potential for camera movement. Since I was shooting a bracketed sequence to combine in Photomatix, that was something I needed to prevent.

Postproduction

To maximize the detail in this high-contrast scene, the five exposure-bracketed frames were combined in Photomatix using the Painterly preset. The image was then converted to black & white using Nik Silver Efex Pro and the High Structure (Smooth) preset. In Photoshop, the sky was brightened to enhance the light in the clouds. Finally, the complete image was processed using the Brightness/Contrast and Levels tool, fine-tuning it for printing.

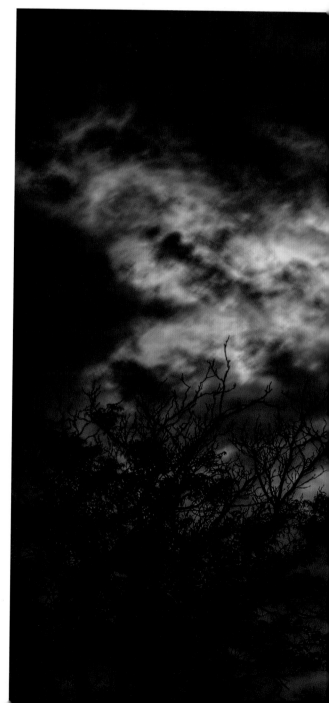

▲ Five bracketed exposures were taken: normal, –2 stops, –1 stop, +1 stop, and +2 stops. The normal exposure was 1/400 second at f/11.

▶ Conversion to black & white using Nik Silver Efex.

▼ Final image.

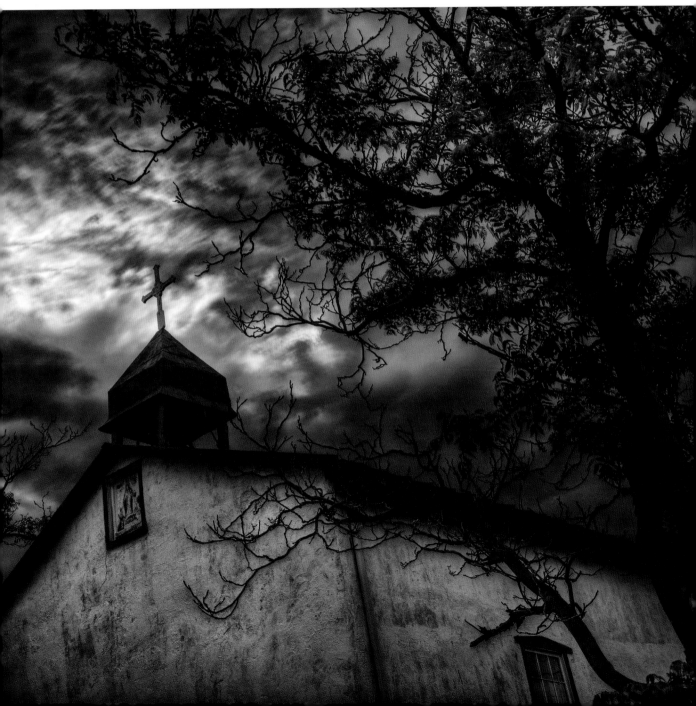

Bidwell Park

Chico, CA (2012)

Shooting

It can be interesting to travel the world in search of spectacular landscapes, but great landscape images can be as close as your local city park. Whether old or new, city parks each have a charm of their own. They reflect the local landscape and how it has been preserved or transformed, allowing people the opportunity to enjoy the outdoors in a natural setting. History has shown that as urban areas developed, people missed their association with nature and created natural areas, close to their homes, where they could still enjoy the great outdoors. Accordingly, local parks may contain a wide variety of trees, waterways, and trails to explore—offering a multitude of photographic opportunities.

This photo was taken in Bidwell Park, located in Chico, CA. The park was established in 1905 and, at eleven miles in length, is the 25th largest park in the United States. I have been taking photos in this park for many years and always enjoy its varied and beautiful sights.

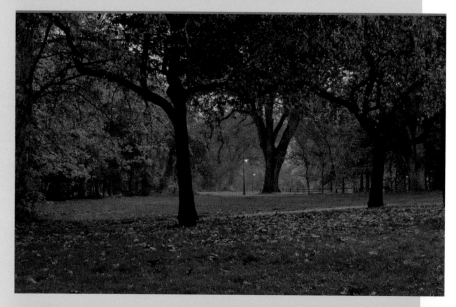

◀ *Top:* Five bracketed exposures were taken: normal, –2 stops, –1 stop, +1 stop, and +2 stops. The normal exposure was 2 seconds at f/18.

◀ *Center:* I used Photomatix HDR to combine the exposures, which yielded this color image.

◀ *Bottom:* Nik Silver Efex was used for the black & white conversion.

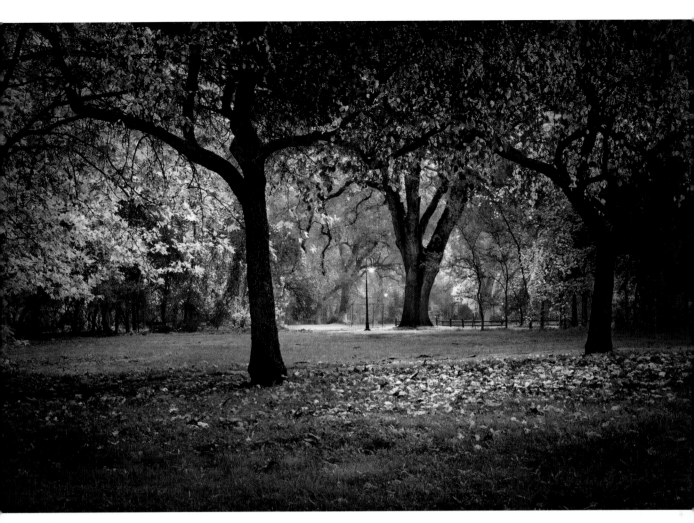

▲ Final image.

Postproduction

I combined five exposure-bracketed images in Photmatix using the Vibrant preset. I chose the Vibrant preset because I wanted the leaves on the trees to add depth to the image through their varied tones. Next, the image was converted to black & white using Nik Silver Efex with the High Structure (Smooth) preset. In Nik, the yellow filter was applied at 21 percent to lighten the leaves. The Structure setting was increased to give greater detail to the grass and tree bark. A control point was added at the lamp in the center of the image to further brighten this area. In Photoshop, the outer border of the image was darkened, bringing greater attention to the center of the photo. Brightness/Contrast and Levels adjustments completed the image for printing.

66 It can be interesting to travel the world in search of spectacular landscapes, but great landscape images can be as close as your local city park. 99

Fort Point

San Francisco, CA (2010)

Shooting

Fort Point is located next to the Golden Gate Bridge in San Francisco. Originally constructed to provide protection for the San Francisco Bay in 1861, the structure still stands firm 150 years later. The interior of the fort contains small areas that were built for defense purposes. The building offers a myriad of interesting photo opportunities that define the structural and cultural landscape of years ago. This scene was intriguing because of the light shining from the exterior on the walls and floor. The building has little color, except for the red of the bricks, making it excellent for black & white images.

Postproduction

Three exposure-bracketed images were taken for this photo. The normal exposure was 2 seconds at f/18 with a ±1 stop bracketing. These images were combined in Photomatix, using the Painterly 1 preset with the Natural lighting adjustment. The resulting image was converted

▼ Final image.

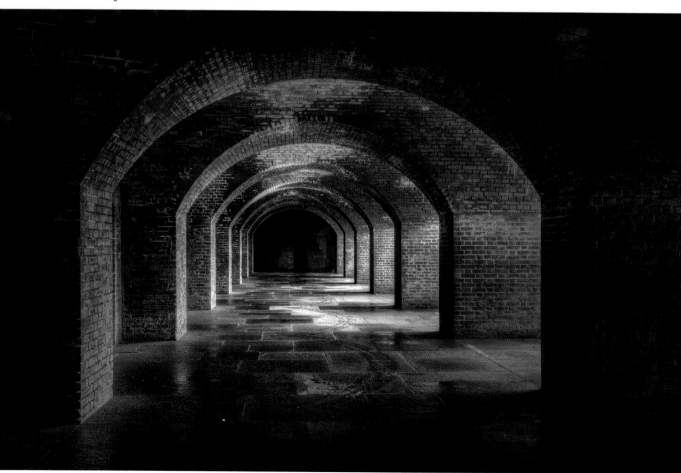

► The three bracketed exposures were combined in Photomatix HDR.

► Nik Silver Efex was used to complete the black & white conversion.

► In Photoshop, the Lighting Effects filter was used to brighten the center of the image and darken the edges of the frame.

to black & white in Nik Silver Efex with the High Structure (Smooth) preset and minor adjustments to the Highlight and Brightness sliders that added detail to the bright areas. In Photoshop, I used the Lighting Effects filter to lighten the back center of the image and darken the edges of the frame. Finally, continuing in Photoshop, I tweaked the Levels and Brightness/Contrast, then applied the Unsharp Mask filter to complete the image.

Statue of Liberty

New York City, NY (2014)

Shooting

It is enjoyable to take photos of popular locations that are recognizable to people everywhere. The Statue of Liberty is an iconic site and instantly known around the world. This image was taken from a ferry going to Ellis Island. Standing next to fifty people, all pointing their cameras in the same direction, I hoped for a memorable photograph.

As the ferry neared the island, I took photos from every conceivable direction. However, this image was the best because of the cross lighting on the statue and the three-quarter view of the face. I took many other images on the island, shooting from below the statue, but I found this image from the boat's higher angle of view allowed a better perspective on the statue.

The camera's shutter speed was set to $1/400$ second to prevent the motion of the ferry from blurring the image.

Postproduction

This photo was made from one normally exposed image that was processed in Photomatix using the single image adjustment with the Painterly preset and Natural+ lighting adjustment. Next, I converted the image to black & white using Nik Silver Efex with the Wet Rocks preset. The green setting was increased to lighten the gown on the statue. The red setting was decreased to darken the sky. In Photoshop, I straightened the statue to a perfectly upright position. I also darkened the borders of the image (using the Burn tool) and lightened the clouds to enhance their appearance. The Clone Stamp tool was also used to remove people from the landing below the statue. This may not have been necessary; however, this image is of the statue and not of the crowds who circled the statue's base. Finally, some overall adjustments using the Brightness/Contrast and Levels tools completed the image.

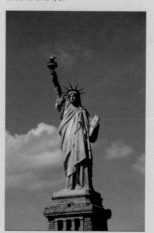

▼ The color image, shot at 1/400 second and f/9.

▼ I opened the single image in Photomatix and applied the Painterly preset, along with the Natural+ lighting adjustment.

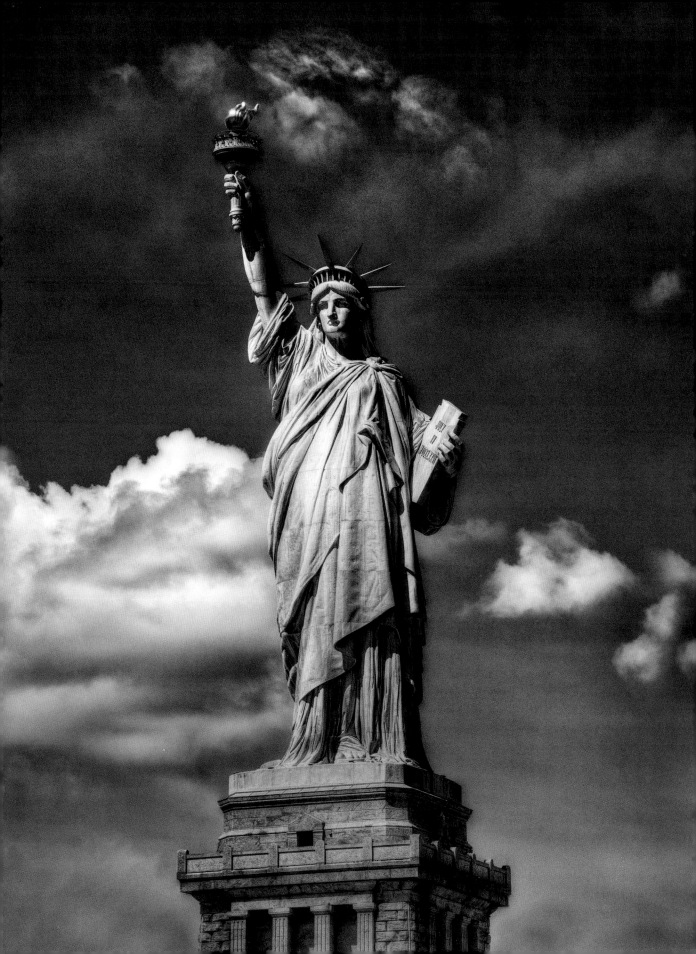

Index

OTHER BOOKS FROM
Amherst Media®

FLASH TECHNIQUES FOR
Macro and Close-up Photography

Rod and Robin Deutschmann teach you the skills you need to create beautifully lit images that transcend our daily vision of the world. *$34.95 list, 8.5x11, 128p, 300 color images, index, order no. 1938.*

Painting with a Lens

Rod and Robin Deutschmann show you how to set your camera in manual mode and use techniques like "ripping," "punching," and the "flutter" to create painterly images. *$34.95 list, 8.5x11, 128p, 170 color images, order no. 1948.*

Advanced Underwater Photography

Larry Gates shows you how to take your underwater photography to the next level and care for your equipment. *$34.95 list, 8.5x11, 128p, 225 color images, index, order no. 1951.*

Lighting for Architectural Photography

John Siskin teaches you how to work with strobe and ambient light to capture rich, textural images your clients will love. *$34.95 list, 7.5x10, 160p, 180 color images, index, order no. 1955.*

Hollywood Lighting

Lou Szoke teaches you how to use hot lights to create timeless Hollywood-style portraits that rival the masterworks of the 1930s and 1940s. *$34.95 list, 7.5x10, 160p, 148 color images, 130 diagrams, index, order no. 1956.*

Painting with Light

Eric Curry shows you how to identify optimal scenes and subjects and choose the best light-painting sources for the shape and texture of the surface you're lighting. *$29.95 list, 7.5x10, 160p, 275 color images, index, order no. 1968.*

DON GIANNATTI'S **Guide to Professional Photography**

Perfect your portfolio and get work in the fashion, food, beauty, or editorial markets. Contains insights and images from top pros. *$29.95 list, 7.5x10, 160p, 220 color images, order no. 1971.*

Photographing Dogs

Lara Blair presents strategies for building a thriving dog portraiture studio. You'll learn to attract clients and work with canines in the studio and on location. *$29.95 list, 7.5x10, 160p, 276 color images, order no. 1977.*

Storytelling Techniques for Digital Filmmakers

Ross Hockrow shows you how to engage viewers through the careful use of shot sequences, perspective, point of view, lighting, and more. *$19.95 list, 6x9, 128p, 150 color images, order no. 1992.*

Commercial Photographer's Master Lighting Guide, 2nd ed.

Robert Morrissey details the advanced lighting techniques needed to create saleable commercial images of any subject or product. *$27.95 list, 7.5x10, 128p, 300 color images, order no. 1993.*

Professional HDR Photography

Mark Chen shows how to achieve brilliant detail and color with high dynamic range shooting and post-production. *$27.95 list, 7.5x10, 128p, 250 color images, order no. 1994.*

Beautiful Beach Portraits

Mary Fisk-Taylor and Jamie Hayes take you behind the scenes on the creation of their most popular images, showing you how each was conceived and created. *$27.95 list, 7.5x10, 128p, 180 color images, order no. 2025.*

One Wedding

Brett Florens takes you, hour by hour, through the photography process for one entire wedding—from the engagement portraits, to the reception, and beyond! *$27.95 list, 7.5x10, 128p, 375 color images, order no. 2015.*

Master Lighting Guide for Portrait Photographers, 2nd ed.

Christopher Grey shows you how to master traditional lighting styles and use creative modifications to maximize your results. *$27.95 list, 7.5x10, 160p, 350 color images, order no. 1998.*

Magic Light and the Dynamic Landscape

Jeanine Leech helps you produce outstanding images of any scene, using time of day, weather, composition, and more. *$27.95 list, 7.5x10, 128p, 300 color images, order no. 2022.*

Shoot to Thrill

Acclaimed photographer Michael Mowbray shows how speedlights can rise to any photographic challenge—in the studio or on location. *$27.95 list, 7.5x10, 128p, 220 color images, order no. 2011.*

Classic Family Portraits

Ed Pedi walks you through the process of designing images that will stand the test of time. With these classic approaches, photos become instant heirlooms. *$27.95 list, 7.5x10, 128p, 180 color images, order no. 2010.*

Shaping Light

Glenn Rand and Tim Meyer explore the critical role of light modifiers in producing professional images of any subject, ensuring smart decisions at every turn. *$27.95 list, 7.5x10, 128p, 200 color images, order no. 2012.*

Step-by-Step Lighting for Outdoor Portrait Photography

Jeff Smith brings his no-nonsense approach to outdoor lighting, showing how to produce great portraits all day long. *$27.95 list, 7.5x10, 128p, 275 color images, order no. 2009.*

Photograph the Face

Acclaimed photographer and photo-educator Jeff Smith cuts to the core of great portraits, showing you how to make the subject's face look its very best. *$27.95 list, 7.5x10, 128p, 275 color images, order no. 2019.*

ABCs of Beautiful Light

A Complete Course for Photographers

Rosanne Olson provides a comprehensive, self-guided course for studio and location lighting of any subject. *$27.95 list, 7.5x10, 128p, 220 color images, order no. 2026.*

Step-by-Step Wedding Photography, 2nd ed.

Damon Tucci offers succinct lessons on great lighting and posing and presents strategies for more efficient and artful shoots. *$27.95 list, 7.5x10, 128p, 225 color images, order no. 2027.*

Shoot Macro

Stan Sholik teaches you how to use specialized equipment to show tiny subjects to best effect. Includes tips for managing lighting challenges, using filters, and more. *$27.95 list, 7.5x10, 128p, 180 color images, order no. 2028.*

Portrait Pro

Veteran photographer Jeff Smith shares what it takes to start up and run an effective, profitable, and rewarding professional portrait business. *$27.95 list, 7.5x10, 128p, 180 color images, order no. 2029.*

Photographing Newborns

Mimika Cooney teaches you how to establish a boutique newborn photography studio, reach clients, and deliver top-notch service that keeps clients coming back. *$27.95 list, 7.5x10, 128p, 180 color images, order no. 2030.*

The Art of Engagement Portraits

Go beyond mere portraiture to design works of art for your engagement clients with these techniques from Neal Urban. *$27.95 list, 7.5x10, 128p, 200 color images, order no. 2041.*

Essential Elements of Portrait Photography

Bill Israelson shows you how to make the most of every portrait opportunity, with any subject, on location or in the studio. *$27.95 list, 7.5x10, 128p, 285 color images, order no. 2033.*

How to Photograph Weddings

Twenty-five industry leaders take you behind the scenes to learn the lighting, posing, design, and business techniques that have made them so successful. *$27.95 list, 7.5x10, 128p, 240 color images, order no. 2035.*

Tiny Worlds

Create exquisitely beautiful macro photography images that burst with color and detail. Charles Needle's approach will open new doors for creative exploration. *$27.95 list, 7.5x10, 128p, 200 color images, order no. 2045.*

Fine Art Portrait Photography

Nylora Bruleigh shows you how to create an array of looks—from vintage charm to fairytale magic—that satisfy the client's need for self-expression and pique viewers' interests. *$27.95 list, 7.5x10, 128p, 180 images, order no. 2037.*

The Right Light

Working with couples, families, and kids, Krista Smith shows how using natural light can bring out the best in every subject—and result in highly marketable images. *$27.95 list, 7.5x10, 128p, 250 color images, order no. 2018.*

Dream Weddings

Celebrated wedding photographer Neal Urban shows you how to capture more powerful and dramatic images at every phase of the wedding photography process. *$27.95 list, 7.5x10, 128p, 190 color images, order no. 1996.*

Light a Model

Billy Pegram shows you how to create edgy looks with lighting, helping you to create images of models (or other photo subjects) with a high-impact editorial style. *$27.95 list, 7.5x10, 128p, 190 color images, order no. 2016.*

The Mobile Photographer

Robert Fisher teaches you how to use a mobile phone/tablet plus apps to capture incredible photos, then formulate a simple workflow to maximize results. *$27.95 list, 7.5x10, 128p, 200 color images, order no. 2039.*

The Speedlight Studio

Can you use small flash to shoot all of your portraits and come away with inventive and nuanced shots? As Michael Mowbray proves, the answer is a resounding yes! *$27.95 list, 7.5x10, 128p, 200 color images, order no. 2041.*

Power Composition for Photography

Tom Gallovich teaches you to arrange and control colors, lines, shapes, and more to enhance your photography. *$27.95 list, 7.5x10, 128p, 200 color images, order no. 2042.*